SKETCHBOOK CHALLENGE

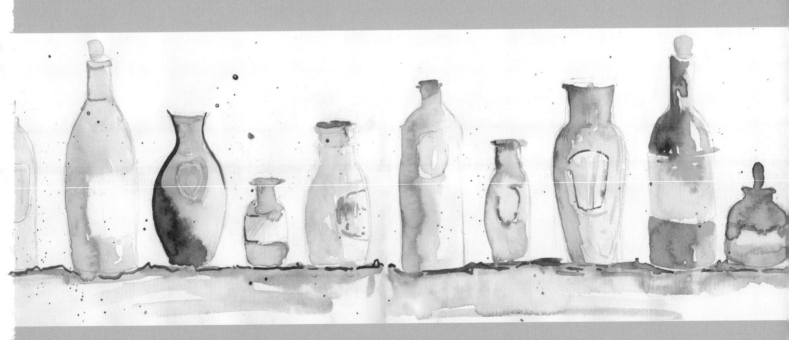

First published in 2022

Search Press Limited
Wellwood, North Farm Road,
Tunbridge Wells, Kent TN2 3DR

Reprinted 2023

Printed in China.

ISBN: 978-1-80092-045-3
ebook ISBN: 978-1-80093-038-4

Suppliers
If you have difficulty in obtaining any of the materials and
equipment mentioned in this book, then please visit the
Search Press website for details of suppliers:
www.searchpress.com

You are invited to visit the author's website:
www.susanyeates.co.uk

Join the next annual 30 Day Sketchbook Challenge on
Instagram by following @30daysketchbookchallenge

MIX
Paper | Supporting
responsible forestry
FSC® C016973
FSC
www.fsc.org

100 prompts for daily drawing

SKETCHBOOK
CHALLENGE

Susan Yeates

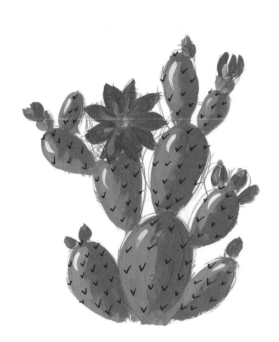

Search Press

CONTENTS

INTRODUCTION 6

HOW TO USE THIS BOOK 8

Why a daily sketching habit? 10

What is a sketch and what is a habit? 12

Why use sketching prompts? 14

MINDSET AND CREATIVITY 16

Process not perfection 19

Be like a toddler 20

The importance of creative play 22

Positive language 24

There is no wrong 26

Make it easy for yourself 27

TOOLS & MATERIALS 28

WARM-UP EXERCISES 34

SEVEN DAYS OF SKETCHING 48

SKETCHING PROMPTS 50

AFTERWORD & NEXT STEPS 158

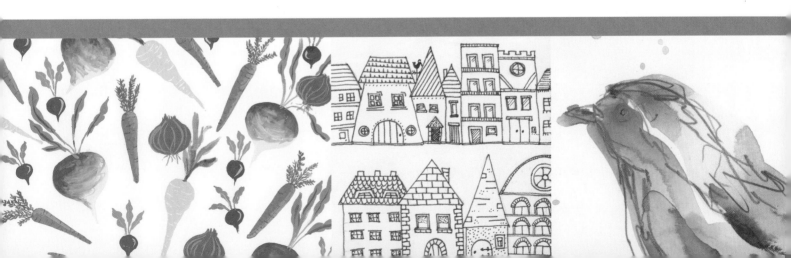

INTRODUCTION

A huge welcome to this big book of drawing prompts – a book designed to help you build up a daily habit of sketching and drawing using just a few simple tools and materials.

I am an artist, author and art tutor based in Surrey in the UK. A daily sketching habit is at the heart of all my creative activities (and I have a lot of those). I find that picking up a pencil, pen or paintbrush in short, regular bursts keeps me in tune with my creativity and inspired for the longer or larger projects that I undertake. After years of experimentation with different sketchbooks and methods of working, I have figured out that small amounts of sketching on a more frequent basis works best for building a habit and boosting creativity. It is this habit – and how I achieve it – that I will share with you throughout this book.

This book is packed full of advice, tips, handy warm-up exercises and, of course, the all-important 100 sketching prompts that you can dip in to whenever you want, or work through in order. Some of the prompts have brief explanations, others a little more information or even step-by-step guides.

This book is aimed at beginners, dabblers, those who haven't picked up a pencil in years and anyone looking to focus on exactly how to add a sketching practice to their art activities – this book, therefore, is for anyone serious about cultivating a daily sketching habit. I will ask you to explore your own reasons behind why you are here, help you shift your mindset about creativity and of course ask you to open that sketchbook regularly and make marks.

My daily sketching habit has built up gradually over the past four years. Of course, there are days when I don't sketch or draw at all due to work pressure, family commitments or being too tired. However, the intention is always there. No one is perfect (certainly not me), and none of my sketches are perfect: they are playful and enjoyable, and are often a foundation for my other creative pursuits.

I regularly use a huge variety of sketchbooks and random bits of paper. Sometimes I use pencil, sometimes ink pens; I enjoy experimenting with paints or just using whatever I have to hand, including my little girl's crayons and felt-tip pens. I have sketchbooks for all occasions, from large A3 ones, in which I can go big and bold, to little portable books that sit in my handbag. This variety provides me with plenty of opportunities to draw and sketch – I never get bored or run out of ideas and I put no pressure on myself to create finished pieces of work. I just sketch...

I share my own sketches, doodles and scribbles throughout this book – some neat and tidy, others loose and messy. The aim of the book is to inspire you and show you how sketching on a regular basis can be a playful, rewarding and very achievable habit. I also share in this book some of my top tips for filling a sketchbook – things I do myself, things that have helped me and those I have seen help others as well.

I suggest you keep learning and reading about art throughout your time using this book. The more you fuel your mind creatively, the more your mind will create. I look forward to sharing this book with you and hopefully seeing some fun, exciting and beautiful sketches from everyone. By the end of this book I promise that you will see huge benefits from the process of opening up a sketchbook and making marks. So, let's get started!

THE 30-DAY SKETCHBOOK CHALLENGE

As someone who is enthusiastic about getting everyone sketching and creating, I host an annual 30-Day Sketchbook Challenge (#30daysketchbookchallenge), starting on 1st January each year. Thousands of people take part to boost their creativity; I email out sketching prompts for 30 days in a row, giving everyone a topic to sketch and draw, along with some tips and words of encouragement – it's super-fun! I initially started the challenge in 2018, and many of the people who have participated over the years have continued to sketch daily.

I hope that this book can provide continued support as well as a host of further sketching prompts.

HOW TO USE THIS BOOK

I recommend reading through the first few sections of this book before jumping to the daily sketching prompts. This will help you to mentally prepare for a daily sketching practice, gather your materials and learn a little bit more about my approach before you get started.

You will find a whole section dedicated to developing a creative mindset, so that you can get the most out of your sketching sessions, however short they may be (see pages 16–27).

After this comes the practical preparation – an explanation of what to expect from the prompts, followed by a discussion on the tools and materials that you might like to use, and then some handy warm-up exercises that you can use to get you loosened up (see pages 34–47).

Finally, you will find all the drawing prompts (see pages 50–157). I have included 100, which is enough to keep you going for months and even more, if you spread them out or repeat them. Some of you may choose to follow the daily prompts as a chronological series of ideas from number 1 onwards, which can certainly be a progressive and logical way to work. It is also extremely satisfying to get to number 100!

However, you may also choose to use this book as a place to find inspiration every now and again. Simply open the book at random, or flick through the pages to choose a prompt that 'speaks' to you, and work with that.

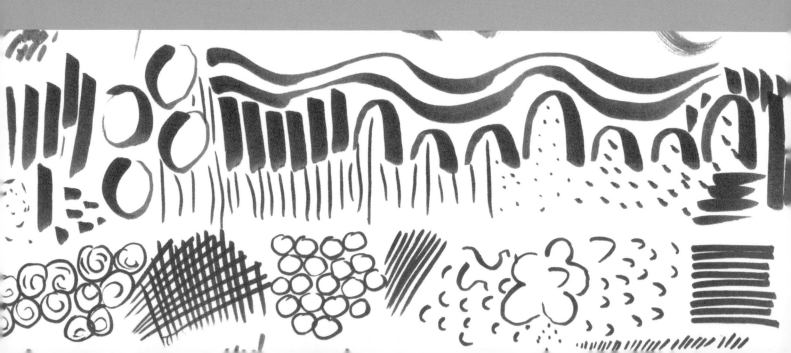

'You can't use up creativity.
The more you use, the more
you have.'

– Maya Angelou

SUSAN SAYS

Look out for boxes like this one throughout the book. These contain tips, further ideas, extra sketching exercises and anything else that I think will be helpful as you fill up your sketchbook pages.

TIP

Set yourself a short time limit such as five minutes; pick a prompt and start sketching. Five minutes is far less daunting than the 30 or 60 you may think you need... and you never know what you might create, even if it is rough or partially complete...

▶ Why a daily sketching habit?

Before we go anywhere, before we talk about materials, techniques, mindset or prompts, it is important to understand **WHY** we are attempting to build up a daily sketching habit.

Why did you buy this book?

Why do you want to sketch every day?

These are genuine questions I ask you to think about. With anything that you aim to do on a daily basis, you need to be really inspired and motivated in order for it to happen. Having a rock-solid, strong reason **WHY** to return to when you lose momentum, have a bad day or are tired will keep you focused and on track.

Let me list some of the reasons that you might want to build up a regular drawing habit:

· To relax and unwind;

· To carve out some 'me-time', maybe getting away from work or a busy family life;

· Cultivate and boost your creativity;

· Remove 'artist's block' or 'drawing anxiety';

· Improve your drawing skills;

· Learn how to use colour;

· To experiment with sketching things that you have never sketched before;

· Enjoy drawing again if you have lost your passion;

· To improve your pencil drawing skills or to learn to use watercolours;

· Learn to see the world in new ways;

· To record a journey or your travels;

· As a way of visually journalling;

· Remove the fear of the blank page;

· To simply fill that stash of sketchbooks;

· Learn how to sketch for the sake of sketching and enjoy yourself along the way;

· To start a career in design;

· To sketch out new ideas for bigger artworks or designs.

In all likelihood many of the reasons listed here will resonate with you, but just one or two will be the main driving force behind why you continue to sketch long after you have put down this book.

DISCOVER YOUR WHY

Turn to the first page of your sketchbook and write down *all* the possible reasons **WHY** you want to sketch regularly.

Once you have done this, I want you to circle or highlight your top three reasons.

Then narrow this down again to just *one* reason, which is your primary **WHY**. This one **WHY** needs to be important to you and you alone. Everyone reading this book (including myself) has very different reasons behind wanting to sketch. The reason you select *must* inspire you and make you keen to open that sketchbook.

Keep this one reason at the forefront of your mind either by writing it down at the front of every sketchbook you use, or by pinning it up on your wall so that you can see it easily.

▶ What is a sketch and what is a habit?

This may sound a little basic, but there is a huge difference between a sketch and a finished work of art, and between a habit and sketching only occasionally. The words 'sketch' and 'habit' have been selected carefully: this is not a book on improving your drawing technique or getting you to complete a single project or piece of art. This is all about doing little bits regularly. It shouldn't take you too long to do each day: I am not asking you to spend an hour sketching every day – simply a few moments.

A sketch is an experiment. It is the equivalent of practising your scales, if you are a musician, not playing a full concert. It is warming up or exercising a few muscles if you are an athlete; it is not the final race. So, for an artist or creative person, it is *not* a finished piece of work. A sketch is all about working out ideas and trying techniques. It is about practising your drawing skills or honing your painting technique. A sketch can be about recording, quickly, a particular time or place, or taking a snapshot of a moment.

A sketch is very often unfinished, smudged or even downright ugly. Sometimes it gets thrown away and sometimes kept. You may take longer to work on a sketch if you feel inspired, but equally, you don't have to. When it comes to sketching, anything goes – a 'just practising' approach to sketching is hugely important, and I will come back to this later on.

And what is a habit? If you think of someone with a coffee-drinking habit, you imagine someone who just *has* to have coffee to function (and yes, I am talking about myself here). Perhaps not the best example due to the addictive nature of caffeine, but the point is that the person is compelled to do something all the time, i.e. drink that coffee. I want you to be compelled *and* excited to open your sketchbook all the time. I want this habit to be fun, exciting, easy and not take up too much of your time. OK, so we may all end up a little addicted to sketching by the end of this book, but it's a fairly healthy addiction to have, and it reaps fabulous benefits.

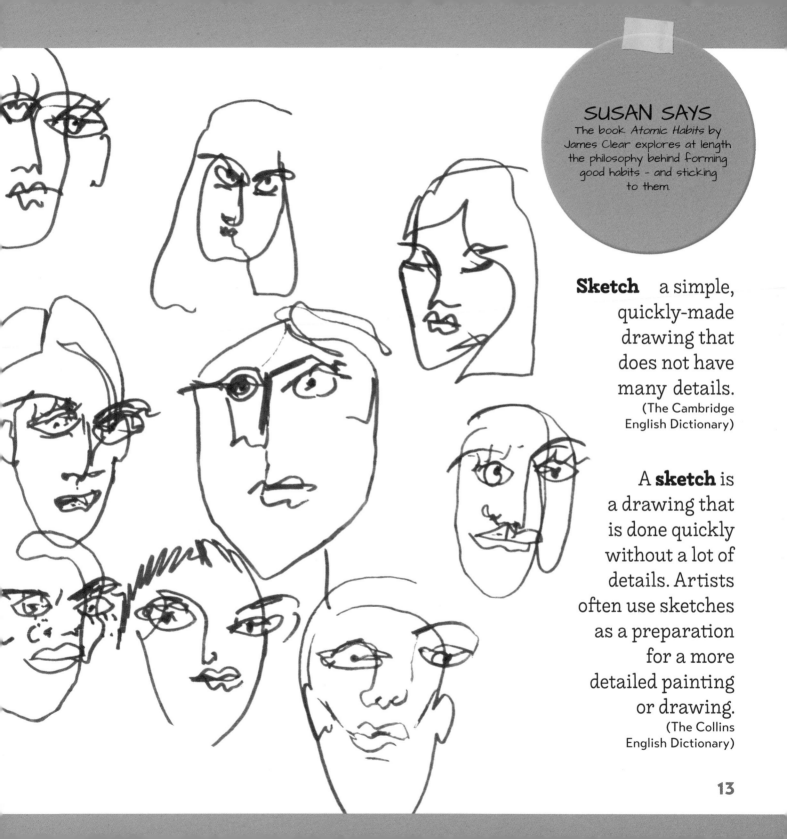

Sketch a simple, quickly-made drawing that does not have many details.
(The Cambridge English Dictionary)

A **sketch** is a drawing that is done quickly without a lot of details. Artists often use sketches as a preparation for a more detailed painting or drawing.
(The Collins English Dictionary)

▶ Why use sketching prompts?

Prompts give us something specific to work on. They narrow down the field from absolutely anything in the whole wide world (which can be hugely daunting) to one specific thing.

I used to find that if I sat down to my sketchbook with no fixed plan, I had to stop and think what to do, and occasionally I closed the sketchbook again because I didn't know where to start. Being told what to draw can be super-helpful in getting the ball rolling, especially if you are a beginner to drawing.

When the drawing prompts are varied each day, they force you out of your comfort zone, encouraging you to tackle something you may never have drawn before (and may never draw again). It keeps your sketching fresh, and you on your toes and constantly inspired. I have also found that I become enthused by topics that I never had an interest in before. It can lead me down a creative path of exploring a whole new theme. For example, one year on the 30-Day Sketchbook Challenge, the prompt was

'biscuit', and I spent five minutes drawing a Jammy Dodger biscuit in pencil. I turned this into a block print, and I created a series of tea towels and hand-printed bags. I would never have done this if it wasn't for that very different sketching prompt.

Drawing prompts are also fun! Don't take them too seriously – this is simply a reason to play with your pencil and exercise those creative muscles. If you make a sketch and decide you don't like it, it doesn't matter, because tomorrow there is a whole new topic on the way. We move on, turn the page, sketch again, and explore a new subject.

Sketching can help you to unwind on a daily basis. Even if you have just 10 minutes available, whether first thing in the morning, during a break in your work day, sitting out in the garden or last thing at night before bedtime, a quick sketch can work wonders to bring a little happiness and calm to your day.

HOW TO BRAINSTORM A PROMPT

If there are days on which you find it difficult to begin (trust me, it will happen - it happened to me when sketching examples for this book!), write the sketching prompt in the centre of the page and start mind-mapping, writing notes or even making little thumbnail drawings around it. Do this quickly and without overthinking - just jot down everything that comes to mind. For example, if the prompt is 'yellow', you might note down things like, 'lemon', 'banana', 'my yellow jumper', 'Lego brick,' or 'yellow brick road'. Once the page is full, you can then choose which idea excites you the most and get drawing.

MINDSET AND CREATIVITY

This chapter is all about tackling our mindset and approach to sketching. This will help not only with a big undertaking – such as completing the 100 sketching prompts in this book – but also in achieving other creative goals.

I think it is so important to apply a positive and supportive approach to creativity, and that begins with acknowledging our own attitudes.

As adults we often have deeply engrained belief systems and thought processes when it comes to art. These may originate from childhood experiences (an art teacher or parent who said you were no good at drawing) or other negative experiences we have had as adults. I believe it is crucial to shift away from negative thought patterns, and rekindle the childlike wonder and curiosity we had for drawing when we were young.

▶ Process not perfection

For effective habit-forming we need to focus on the 'process' of creativity rather than the end result. By this, I mean the process of finding your sketchbook, opening it up and making a sketch or doodle of some form, however rough or quick.

Sometimes, as creatives, we just aren't in the mood and the ideas aren't flowing. This is when we need to dig deep and just start making marks. These are the times when the warm-up exercises from this book serve to shake us out of any funk and switch on our creative brains (see pages 34–47). After a while, opening your sketchbook and drawing becomes a solid habit, and the process of sketching proves comforting in itself.

When we persevere and trust the process, we begin to let go of our need to achieve perfection – something that in art and creativity is almost impossible. If we aim to do something daily, in whatever short, rough or quick form that may be, we are prioritizing quantity over quality. This is certainly what many professional artists and designers do: schedule regular creative sessions and preserve this time at all costs. They come to the artistic process (the easel, the printing press, the computer) regardless of how they feel. Remember that, in the context of this book especially, a sketchbook is a place for creative play and building a sketching habit – it is *not* a finished piece of art in book format. A tour of my own sketchbooks will reveal many messy pages that are far from perfect!

Small daily doses of creativity will serve you well in the long run and, if you are anything like me, you might be doing one creative thing when another creative idea springs to mind. I will often be sewing or trying a warm-up drawing exercise when an idea for a sketch or print comes to mind – because I am relaxing into *something*. The creative brain has had space to relax, think laterally and process other thoughts that may well have been there but hadn't previously been given the chance to pop out.

This is exactly why we focus on the process above achieving perfection. You need to give yourself space for your creative mind to be free.

▶ Be like a toddler

'Being like a toddler' is a mindset shift that asks you to think slightly differently when approaching your sketchbooks. It means being more mindful in our approach, but with an added layer of fun and curiosity. Mindfulness is simply existing in the present moment, absorbing every sense, and *feeling* what happens, forgetting both the past and the future and staying aware of our current experience.

As a mum myself, watching a super-curious small person hold a crayon for the first time or make a total mess with paints has highlighted to me just how much we change as we grow older. The world of making art is free and uncomplicated for a toddler. When my little girl picks up a crayon, she doesn't think, 'what will I draw today?' or 'does this red squiggle look realistic?' – she is making marks and expressing herself for the pure pleasure of it. Marks are made within seconds – sometimes big expressive marks, sometimes tiny marks and dots but never with any pre-planning. Certainly, with very young toddlers it is all about the feeling, the movement and the question, 'what happens if?' Once the drawing is done (or she gets distracted by something else), she simply moves on. She may draw on the back of the paper, tear it up, draw over it with something else or throw it on the floor. She is completely in the moment and never overthinks or worries.

Even now that my daughter is four, and starting to make drawings that represent things, there is an innocence and curiosity to her creativity. Sometimes a mark is made and she says, 'look, Mummy, a rainbow' or 'it's a funny crab'. She doesn't *intend* to draw a rainbow or a crab – she just sees this in the marks; or one mark starts to look like a rainbow and she goes with it. There is always a sense of pride in having made those marks and done a drawing – none of this 'is it good enough?' or 'I did that wrong'.

So with this in mind, are there ways that you can apply this childlike approach to your own art? Maybe you plan a little less, maybe make more mess or throw away your sketches when you are done with them, in an attempt to be less precious. Hopefully, by reminding yourself that this is all just for the fun and curiosity of it, the pressure will lift and you can get back to the pure pleasure of expressing your creativity. At the end of the day, it's just a little sketch. No one is judging you.

With a few small mindset changes, we can all approach our creativity and art in a new and fresh way, and be more like toddlers (but no tantrums please!).

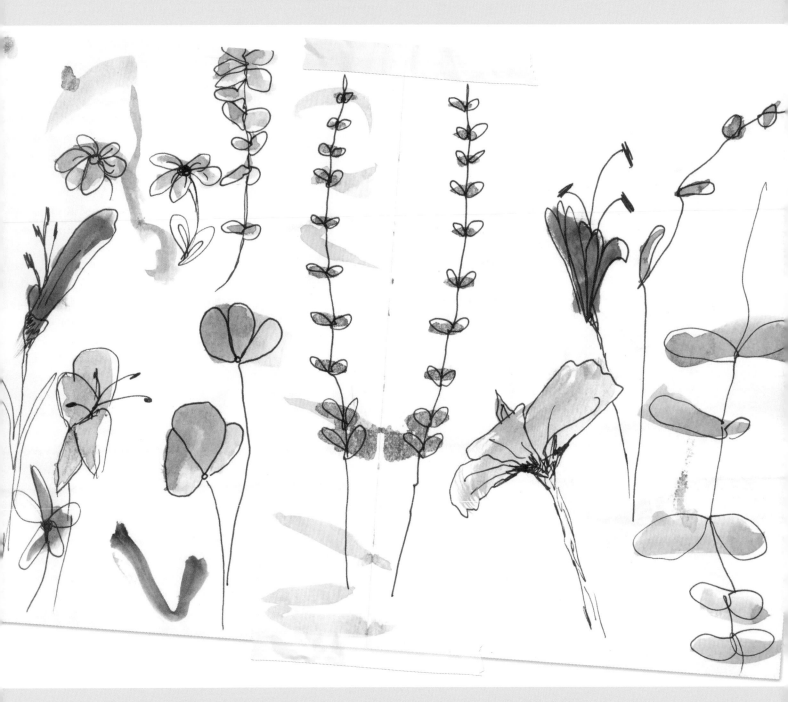

▶ The importance of creative play

Creative play, to me, means doing anything creative just for the sake of it. This often involves doing something easy, such as doodling as I watch TV or practising warm-ups in my sketchbook. It might also be taking photographs of my art materials, painting the wall in my garden with a mural, arranging my paints in colour order or drawing rainbows with my four-year-old.

The warm-up exercises on pages 34–47 are great example of creative play as they will allow you playtime in your sketchbook. Playing should carry no pressure and should be pleasurable. I would rather play in my sketchbook than do a 'serious drawing'. I will often tell my family that I am off to play, rather than work, in my studio. Creative play always makes me happy and relaxed, and some of my best art has been produced when I am playing and under no pressure to produce a finished piece of art. This is why sketchbooks are so good as a vehicle for creativity – they allow creative play in small chunks through enjoyable exercises.

'Creative play' is a concept used in education to help children develop physically, socially, mentally and emotionally. As adults we sometimes forget to play, to mess about and be silly.

Here are some of the benefits of creative play:
- It develops the imagination;
- It sparks curiosity – 'what happens if...?'
- It is relaxing;
- It is a method of creative habit-forming;
- Creative play exercises the 'physical' creative muscles; it builds up your fine motor skills and ability to use specific materials and develop dexterity with a pencil or paintbrush;
- It exercises the creative side of your brain;
- It helps you learn to understand yourself – to express yourself and find your own style;
- It is useful for critical decision-making in your art – when you need to make an important decision, such as 'does this colour work with that one?', you have already practised making these decisions when playing. Then, when you need to make decisions on more important works, your brain is used to making choices and it gets easier.

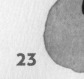

WHY NOT TRY...?

CREATIVE PLAY

How could you play creatively a little more? Are there things that you enjoy that seem silly and are not classed as 'serious art' that you can explore? Whatever sparks your joy – try a little more of it!

When I want to play creatively I tend to make colour swatches of all my art materials and play with colour mixing with no end purpose in mind. I have included this as a warm-up exercise on page 46 as it is also really helpful for getting to know your materials.

Think of three things that you consider to be creative play that don't involve a sketchbook – creative things you can do *just for fun*. Try to do one of these things today for at least five minutes!

▶ Positive language

As adults, we can be apologetic or self-deprecating about our work. These are deeply engrained attitudes instilled at an early age; if I had a coin for every time someone told me that they 'can't draw' or 'aren't creative', or 'it went wrong', I would be a rich woman!

So, why is this important? The way we describe our creative activities can have a huge impact on our thoughts and ultimately our pleasure and success. Constantly telling ourselves that we 'can't do it' or that we are going 'wrong' blocks our ability to relax, and prevents us opening our minds to discover and create new things.

Positivity is important in every walk of life. No athlete starts a race thinking, 'I can't do this' or 'I am terrible at running' – almost the exact opposite! So, why, when we attempt to draw for the first time in a long time, do we give ourselves such a hard time?

REPLACE NEGATIVE WITH POSITIVE

One of the quickest ways to make big changes to your thinking about drawing is to address your language. Listen to the negative words or phrases you use frequently, and try to replace these with a more positive set of words. So, instead of saying, 'that went wrong', say something like, 'that was an interesting experiment'.

- Instead of saying, 'I've no time to draw today', try saying, 'I've got five minutes to draw something'.
- Instead of saying, 'drawing faces is hard', rephrase with something like, 'I'm going to keep practising drawing faces'.
- Instead of 'I hate not being able to do this,' say, 'I love learning and being a beginner again'. You get the gist!

Observe your own language towards sketching closely as you progress through the book. Make these little changes where you can – it is amazing the difference this can make.

NO EXCUSES!

Don't make excuses or apologize for your work. Instead of saying, 'I didn't have much time today' about a swiftly-drawn sketch, simply state the facts: 'Pencil sketch, 10 mins'. If you did the best you could with the time, the materials or the mindset that you had at that very moment, then that is good enough for me and it should be good enough for you too!

AFFIRMATIONS

An affirmation is a word, phrase or sentence that you repeat to yourself to reinforce a positive message. It is a little bit like a mantra or motto that you live by. Affirmations help to re-train the brain, through positive language, to encourage a new way of thinking – ideally a positive and helpful one. For example, if I said to myself every day, 'I love drawing teapots', you can imagine that after a while this really will help me to love drawing teapots. Affirmations can be specific to sketching, or more generally related to your creativity. They can also be helpful if there is a particular creative barrier you wish to break. For example, if you are guilty of spending a lot of time looking at other people's sketches rather than doing your own, you could use an affirmation such as 'Create; don't consume' (see opposite page).

1. WATCH YOUR LANGUAGE!

Over the next week, note down any negative words that you use, and when, where and how you use them. Try to replace these words with positive ones instead. Has this changed your attitude to your creative practice? Here are some suggestions of positive words to use:

fantastic, good, right, can, do, will, worked, have, excellent, did, good, success, always, abundance, succeed, experiment...

2. REFLECT ON YOUR WORK

Study a piece of your own creative work. Spend about five minutes making negative notes: all the things you don't like about it or are disappointed with. Then spend double that time making positive notes: what you do like, what you did well, what makes you happy. How does this exercise make you feel about this piece of work?

3. CREATE AFFIRMATIONS

Come up with three positive affirmations about your creativity, which will help you to reframe your sketching practice in a more positive light. Use the examples below to get you started, if you need to. You could even make these into pieces of art. Repeat the affirmation(s) regularly.

I am an artist
My creativity flows freely
I am confident and skilled in my creative work
I am proud of my...
I enjoy...
My creativity makes me happy!

'Create; don't consume'

▶ There is no wrong

It's important to stress that when it comes to your sketchbook: *there is no wrong*. There are no rules, no exams, and no one is assessing you. The sketchbook police won't come to take you away if you go off-tangent, cross something out or dislike your work. This is *your* place for experimenting, learning and, yes, I'm going to say it: for going wrong.

A huge part of any learning process is trying new things – sometimes these things work and sometimes they don't. The only way to progress is to try, and see what works, to make mistakes and learn from them. The only one judging you is yourself.

Let's remind ourselves what a sketch is – 'a simple, quickly-made drawing that does not have many details' (see pages 12–13). It can be preparation for a more finished piece of work or just an exploration of a subject matter. You can fill your sketchbook pages with whatever you want: they are *your* pages.

The only
one judging
you is
yourself.

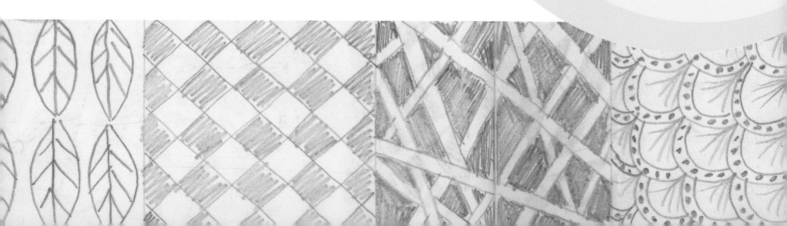

▶ Make it easy for yourself

Making sketching convenient and easy will help to solidify your sketching habit. It's logical really, but not something that we always do. Many people (me included) feel that we need a long block of time, or the perfect environment, in which to draw – when the children aren't demanding your attention, when all the 'work' is finished or even a lovely studio space to make art. If I only ever waited until my work was done, until all the cleaning was done, or until I had set up the perfect space in my studio, there would never be the perfect time to sketch and I would have many empty sketchbooks.

What I, and many others, do is focus on making sketching convenient rather than perfect: the practical steps you take to make your materials more accessible will shift your mind from thinking, 'it's all an effort' to 'well, this is easy'.

You may wish to select a small sketchbook to start with as it will be quick to fill and thus, less daunting. The effort needed to fill a large page can be too great if you aren't used to doing so.

In addition, you can prepare a small, easy-to-grab sketching pack containing just a few essential materials, which lives alongside your sketchbook (see page 32).

The final step is to place this sketchbook and essential materials somewhere that is easy to access. Think about where you might be when you want to sketch:

- Is this in the evening while watching TV? *Put your sketchbook on the coffee table by the sofa.*
- Is it at work or on the journey to work? *Put your sketchbook in your work bag.*
- Is it in the car when you are waiting for your children to come out of school? *Put your sketchbook in the car.*
- Is it in bed before you fall asleep, or just as you wake up? *Put your sketchbook on your bedside table.*

In fact, why not put a sketchbook in all of these places? I have sketchbooks littered about the house so that when I have a few minutes I can quickly and easily get going!

TOOLS & MATERIALS

The requirements for building a regular sketching habit are pretty basic – something to draw with and something to draw on. As an artist and sketchbook addict, I have my favourite drawing materials and sketchbooks, but I do not want a lack of materials to be a barrier to starting. If all you have to hand is a well-used biro and scrap of paper torn from a notebook, then you can still get sketching.

For those who are new to sketching, simply use what you already have: this might be a few pencils and a cheap sketchbook, some old watercolour paints or even your children's colouring pencils and crayons. You can always stock up with more tools and materials as you learn what you enjoy.

If you sketch regularly, you may have more than enough materials to hand. I have unopened sketchbooks, new pens and packs of pencils crammed into my home and studio. Sometimes I think that buying art materials is a hobby in itself!

Therefore, whether you are a beginner to drawing or someone with loads of half-full* sketchbooks, I suspect that you already have what you need.

* Notice that I use the phrase 'half-full' rather than 'half-empty' here when referring to these sketchbooks. This is the concept of positive language in action, when discussing sketchbooks (see page 24 for more information).

SOMETHING TO DRAW ON

I highly recommend investing in a small sketchbook that you are comfortable using. Most of my materials for daily sketching fit into a handy little bag or pouch. This makes it easy to fit sketching into my day, whether I am at home or out and about.

There are several considerations when I choose a sketchbook:

Cover I prefer a hardback cover as it gives a little support, so I can lean on it when I am sitting on the floor or out on location. A softback cover can flop slightly, meaning that you may need to lean on a table or drawing board for support. A hardback cover will also protect your work – I often throw a sketchbook into my bag when I'm leaving the house and this protection means that my drawings won't get damaged.

Think also about whether you would like a spiral-bound sketchbook (where you can turn the pages over easily) or one with a bound spine. I usually work in a mixture of both formats.

Size This is down to personal preference but also convenience. I recommend starting with a small, pocket-sized sketchbook (A6 – 10.5 x 14.8cm or roughly 6 x 4in) for daily prompts. It means that the space you have to fill each day is small and manageable and you can get the sketch completed quickly: remember that you won't always have lots of time in which to sketch.

In addition to a small portable book, I have several larger sketchbooks that I use to explore ideas with a little more space. If you are used to working larger and prefer the space for bigger marks or like to work on a big study over a number of days, then, of course, please continue this. It is important that you feel comfortable working in your sketchbook, and that you want to sketch in it.

Paper quality I have two conflicting thoughts on paper quality. The first is that all you really need is something cheap and cheerful. A cheap sketchbook often encourages you to sketch without the fear of making a mess or ruining an expensive, precious book. I find that the sketchbooks that I *don't* use are those I have spent a lot of money on. Conversely, my cheap sketchbooks are often very well used.

The second thought is that you should choose a sketchbook with a paper quality that suits the materials that you use. I like a good-quality paper that allows me to draw on both sides without the paper warping or the ink bleeding. Most papers in cheap sketchbooks are thin, so when you use an ink pen or paint, for example, the paper can get damaged. I regularly use hardback Moleskine® sketchbooks with 90gsm (60lb) paper for works in pencil, ink pen, brush pens, charcoal, coloured pencil and small amounts of paint. I buy separate sketchbooks with mixed-media or watercolour paper (250–300gsm, or 90–140lb) if I intend to sketch in wet mediums such as watercolour, gouache, acrylic paint or drawing ink.

Loose sheets of paper So far I have talked almost exclusively about sketchbooks, but all the above advice applies to loose sheets of paper as well. You can use cheap printer paper, or buy sheets of high-quality drawing paper in all sizes. You can set them on a drawing board or easel for sketching and you can always just throw a sketch away if you don't want it (or like it) without having to tear a page out of a book. You can also scan in sketches and drawings a little easier if they are on separate sheets with nothing else on the back.

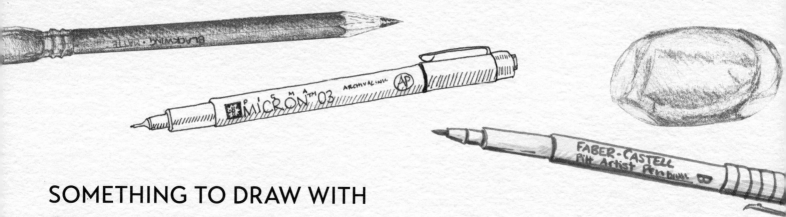

SOMETHING TO DRAW WITH

I don't want to spend too long discussing any one art material and how to use it. There are countless books dedicated to honing pencil, pen or watercolour techniques, so if you do want to explore a material in more depth, search for a specialist book on that subject.

You also don't need to go out and buy the same materials that I use – start with what you have already and build up your kit gradually. Many of my sketchbooks are worked on with a single pencil or pen. On these two pages, I show you some of the most popular drawing tools. I recommend using tools that you feel comfortable with, that are portable, easy to use and don't require too long to dry. A pencil or fine-liner pen is the perfect choice for sketching on a daily basis.

Experiment with your materials, and have fun: this is a key principle in enjoying sketching and continuing your habit – the love for your materials and playing with them. If there is a medium you don't enjoy – don't use it! Remember, you are doing this for enjoyment, and for your main reason **WHY** (see the exercise on page 11). If you don't enjoy it, it will stop becoming a habit and become a chore – and I am not a fan of chores.

On this page:
Pencils (soft and hard)
Ink pens/fine-liner pens
Eraser
Pencil sharpener

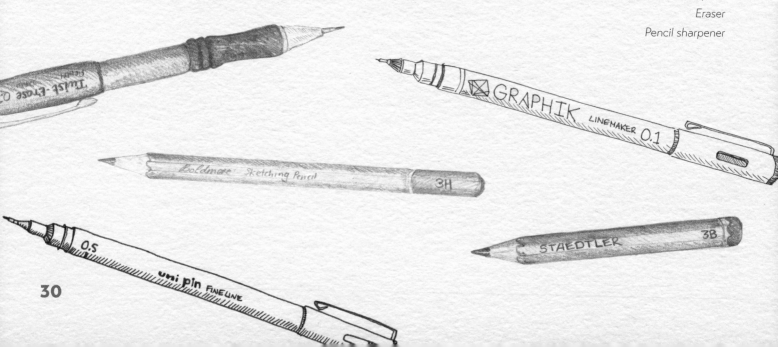

GETTING TECHNICAL...

Technical ability will always improve with practice, whether that is learned through books, classes or self-practice, i.e. just sketching. In some ways it is better to explore your own style of sketching and drawing than to emulate another person's technique. Realism isn't everything when it comes to drawing; although understanding perspective, scale, tone and composition can be handy tools in navigating the depiction of objects, they can sometimes hinder free expression and personal interpretation. *Never let a lack of formal training hamper your enthusiasm for sketching and drawing the world around you.* You already have everything you need to sketch and gain a lot of joy from doing so.

On this page:

Pair of compasses

Soft pastel

Colouring pencil

Derwent Inktense pencil (a type of watercolour pencil)

Willow charcoal

Pencil

POSCA pen

Lamy fountain pen

Artists' brush pen

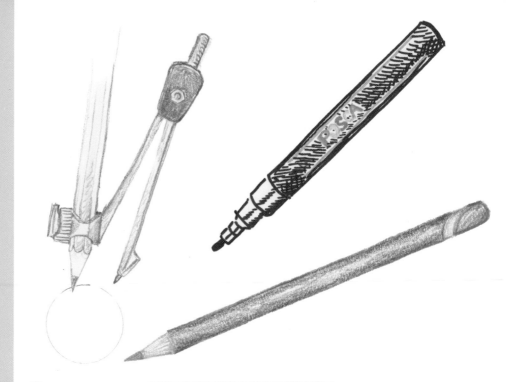

Never let a lack of formal training hamper your enthusiasm for sketching and drawing the world around you.

CREATING YOUR OWN PORTABLE SKETCHING PACK

Create your own small, portable kit of essential materials and tools for your daily sketching habit. You may wish to have a selection of materials similar to mine, or other materials that you love to use – either is fine.

Here is what I have in my portable sketching pack:

- Small hardback Moleskine® sketchbook;
- Small range of pencils from 3B to 3H – this usually includes 2B, B and 2H;
- Mechanical 2B pencil;
- Range of fine-liner pens, from fine to thick (UniPin are my favourite and I tend to have a 0.2, a 0.5 and a 0.8);
- A black Sharpie marker pen;
- Pencil sharpener;
- Eraser;
- TomBow fine eraser (shaped like a pencil) for fine detail erasing;
- Pair of compasses;
- Fountain pen with black ink (and a spare cartridge);
- Two small bulldog clips for keeping my sketchbook open;
- Small metal ruler;
- Grey brush pen;
- White gel pen for adding highlights.

Sometimes I also include a travel set of 12 watercolour paints or some coloured watercolour pencils.

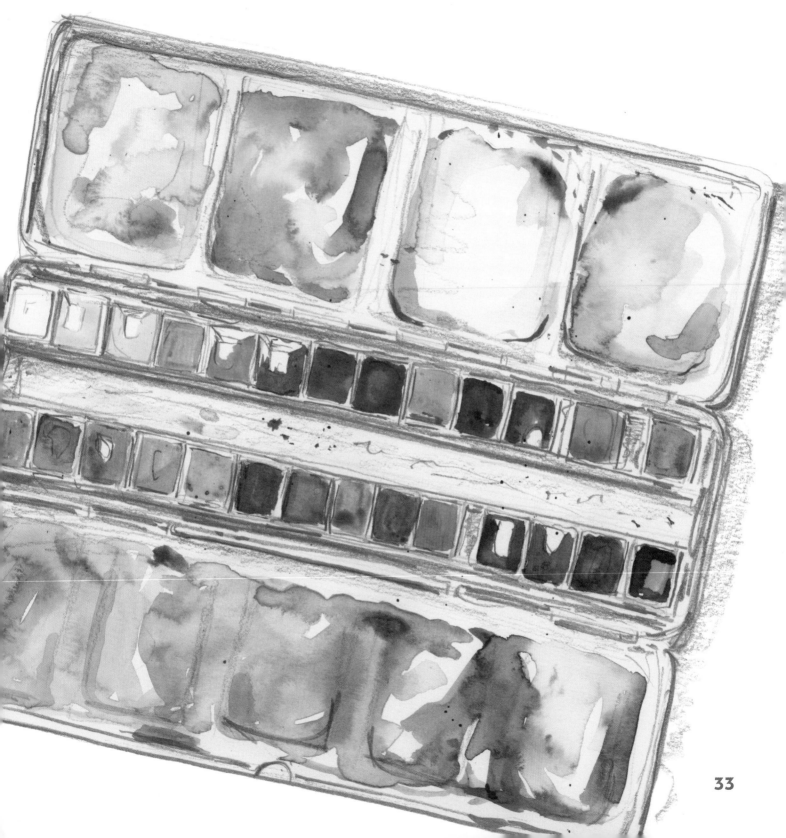

WARM-UP EXERCISES

This chapter contains six separate warm-ups exercises – quick and easy, creativity-boosting activities that are accessible and approachable ways to get started with your sketching.

Motivation to sketch and draw fluctuates daily, depending on mindset and circumstances, even for the most creative souls. These exercises can help you to avoid that fear of the blank page, providing you with a simple starting point – a diving board to launch you into the swimming pool of sketching!

These warm-up exercises provide a route into the 'Zone': that wonderful place where time almost stops still and you are in your full artistic flow – creating and making with ease, often producing your best work and having unhampered fun along the way. The exercises help us to put aside unnecessary thoughts, hone our muscle memory in terms of holding and using a drawing implement; they get our hand–eye co-ordination working and allow time for the mind to settle into that creative place. Think of these exercises as little jogs before the big race; we are stretching those creative muscles so that they are ready to perform when we want to take on a more challenging or artistically demanding task.

I teach these six exercises in many of my online sketching courses and I personally use them if I am feeling a little stuck for where to start, or have just five minutes to play. These are all easy to do and suitable for beginners as well as seasoned artists.

I recommend trying out each of these exercises separately (maybe one a day) and see what happens. Make an exercise the first thing you do when opening up your sketchbook for the day.

Oh, and don't forget that you can repeat these warm-up exercises as often as you want. This section of the book is one you can return to frequently.

1. MINDFUL CIRCLES

This simple doodling practice helps induce mindfulness, or relaxation and calm. I have a whole sketchbook dedicated to this practice of drawing little circles. It is a firm favourite that I return to whenever I want to warm up and forget about anything other than my sketchbook.

TOOLS & MATERIALS
· Small sketchbook or piece of paper
· Fine-liner pen

INSTRUCTIONS
1. Take a deep breath and relax.
2. Draw a small, complete circle somewhere on the page.
3. Move your pen elsewhere on the page and draw another circle.
4. Keep moving the pen around the page to draw more circles in any size and arrangement you like. Do this for just a few minutes, or get carried away and fill the page!

The only rules are:
· Use a pen (so your drawing can't be erased);
· Don't plan anything before you start – you may well find that a pattern develops as you draw, and that is fine: just go with the flow;
· Draw circles of any size across your paper;
· Make sure you complete each circle;
· Slow down and observe what you draw as you draw it;
· Take as long as you need or want;
· Breathe slowly and steadily.

1.

2. 30 SHAPES
FIVE MINUTES – ONE PEN

This warm-up is particularly effective at boosting your creativity, so is definitely one to use when you feel a little flat, have run out of ideas and need to kickstart that creative side of your brain again. It encourages the brain to come up with new ideas, within a fixed framework.

Try this warm-up a few times and see what happens; you can use it as a regular creative exercise. Oh, and have fun – you can make your doodles as silly as you like.

TOOLS & MATERIALS
· Piece of paper or sketchbook
· Pen or pencil
· Stopwatch or clock (timer)

INSTRUCTIONS

1. Select a basic shape to work with, such as a square, circle, rectangle or triangle.
2. Draw your chosen shape 30 times on your paper. Keep the size to between 2–4cm (1–2in) – not too large. The shapes do not need to be evenly placed, or even geometrically accurate. A wonky circle will work perfectly well for the purposes of the exercise. You can simply draw rows of the same shape on the page.
3. Now set yourself a timer – five minutes is perfect.
4. Go back to your first shape and draw something inside it – make some small lines, dots or marks, turn it into a simple interpretation of an object, such as a wheel for a circle, or draw a boat or a smiley face inside.
5. Fill in all 30 shapes! Working quickly like this makes the brain switch into creative mode and prevents you from overthinking or planning the shapes too much.

TIP
If you find having a timer for this exercise a little stressful, turn it off, but make sure you work quickly to go with the flow as you work through the shapes.

3. MARK-MAKING PLAY

I am very excited to share this particular exercise with you: it will help you to loosen up, get a little messy and experiment with your materials. You will need a selection of materials to work with – I recommend using only black materials such as black brush pens and black paint so that colour doesn't distract from the essence of the mark-making.

SUSAN SAYS
It is interesting to experiment with marks made by felt-tip pens, or any pens that have dried out and are nearly ready to throw away!

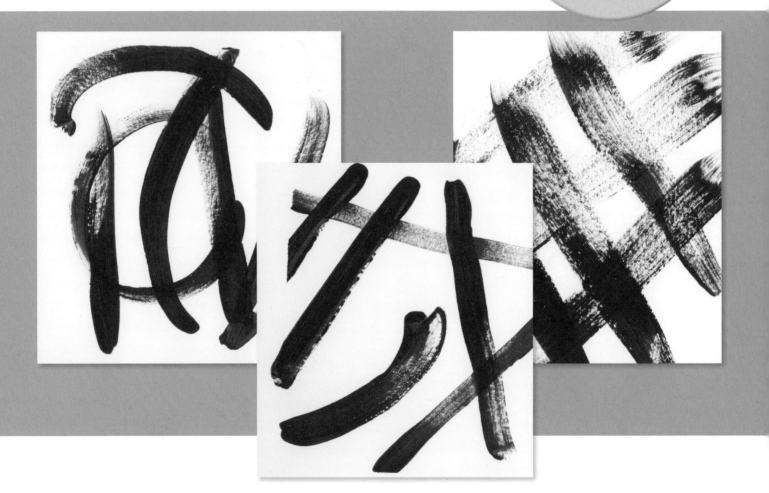

SUGGESTED TOOLS & MATERIALS

· Sheets of white cartridge paper or a large sketchbook page (the larger the better)
· Black brush pen or similar
· Black paint (acrylic, poster paint, gouache)
· Plastic paint palette
· At least two different paintbrushes (one large and one small)
· Bubble wrap
· Other items to dip into the paint (pieces of foam, wadding/batting, cotton wool, scraps of fabric, cocktail sticks, lollipop sticks or kitchen paper)

You can use any or all of the suggested materials above or find your own materials to work with: the principle is the same – make lots of marks!

INSTRUCTIONS

1. With a brush pen, start making marks across the page. You aren't making patterns – just experimenting with the marks that the pen can make: thin lines, thick lines, swirls, dashes and waves. Give yourself at least 10 minutes to play and experiment.
2. Move on to a new page. Using a large paintbrush, dip it in the paint and again experiment with making marks. Dab the paint, splat it, flick it, make lines, dots, dashes and swirls. Try using lots of paint on your brush and also try a dry brush. See what happens.
3. Switch to a small brush and a new page and repeat step 2.
4. Finally, try dipping into the paint things like bubble wrap, cotton wool, scraps of fabric and anything else you can think of – even your fingers! Get really messy and fill several pages or sheets of paper as you explore.

Leave it all to dry, sit back and admire your work!

TAKE IT FURTHER

· After working with black and white, try doing this exercise in colour.
· Save the pages of marks you make: cut and stick them into your sketchbook as backgrounds or as collage art. You could even cut out interesting little sections and frame them as mini artworks.

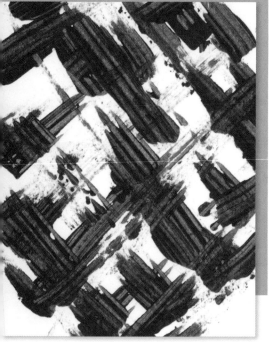

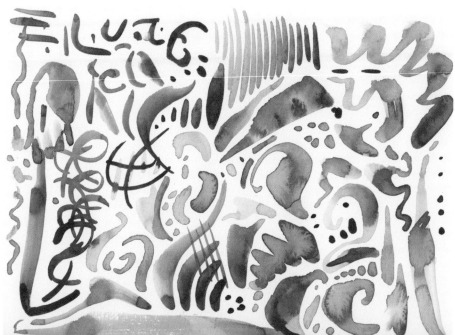

4. DON'T LOOK!

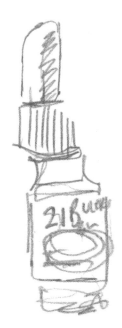

This exercise will guide you through blind contour drawing, which is a way of building up your powers of observation – a key skill for any artist.

In blind contour drawing, you look only at the item you are drawing and not at the paper or the drawing itself. In other words, you are purely observing and not worrying about what your pen is doing. Some artists cover their hand as they work; others simply keep their focus ahead on the object. This exercise is really important for honing those observational skills and removing the 'worry' about what the finished sketch looks like.

TOOLS & MATERIALS

· Piece of paper or sketchbook
· Pencil
· Object to draw

INSTRUCTIONS

1. Select an object to draw, such as a cup, jug or piece of fruit – whatever you have to hand. Set the object in front of you so that you can see it clearly.
2. Look at the object carefully and decide where to start. Then cover the paper so that you can't see what you are drawing, or restrain yourself and don't look down!
3. Draw what you see – depict every bump, curve and the overall shape of the object. Observe the object in detail, to create a line drawing.
4. Keep drawing until you think you have completed the shape. It should take you only a few minutes. The results can really be quite interesting and sometimes hilarious.

I recommend doing this exercise at least once a week: it is a helpful exercise in building up hand–eye co-ordination and stopping our brain from 'filling in the gaps' – we are just drawing what we see, not what we *think* an object should look like.

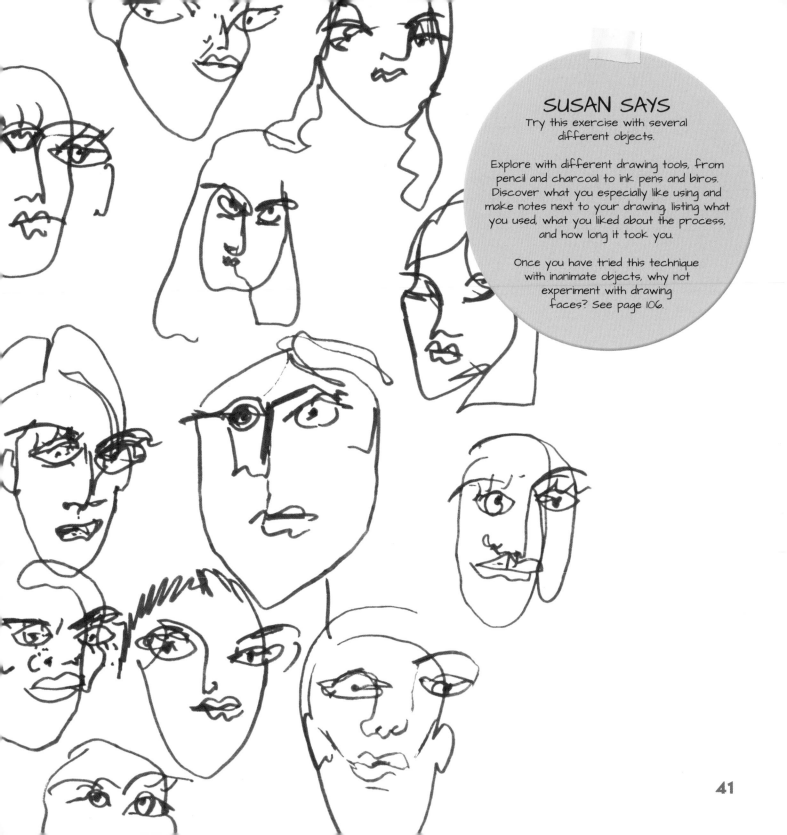

SUSAN SAYS

Try this exercise with several different objects.

Explore with different drawing tools, from pencil and charcoal to ink pens and biros. Discover what you especially like using and make notes next to your drawing, listing what you used, what you liked about the process, and how long it took you.

Once you have tried this technique with inanimate objects, why not experiment with drawing faces? See page 106.

5. SMALL OBJECT OBSERVATION

This exercise provides a set of quick drawing practices that serve as a warm-up routine, and help you to explore small objects and become more confident in drawing them. The idea is to do the whole set of exercises in one sitting, which will take about 20 to 30 minutes. This warm-up is one to dip into before you embark on a larger drawing, such as a still-life arrangement, or as a daily prompt if you are ever stuck for ideas.

TOOLS & MATERIALS
- Three pencils: HB, 2B and 4B
- Sheet of A4 paper (or larger)
- Piece of charcoal
- Fine-liner pen
- Chunky marker pen
- Stopwatch, clock or timer
- Small everyday object to draw

BEFORE YOU GET STARTED...

- Complete this exercise in one sitting to keep the flow of the study going.
- Keep turning your object around between drawings to draw from all angles.
- The aim is to complete the studies within a minute – keep them short. The whole set of exercises should be achievable within 30 minutes.
- You may have to draw over your own sketches at times, but this will keep the sketching loose and prevent you from becoming too 'precious' about your drawings.
- Make sure you have all of your tools and materials to hand before you begin so that you don't have to interrupt the flow of your work.
- Try this exercise several times with different objects.
- Have fun!

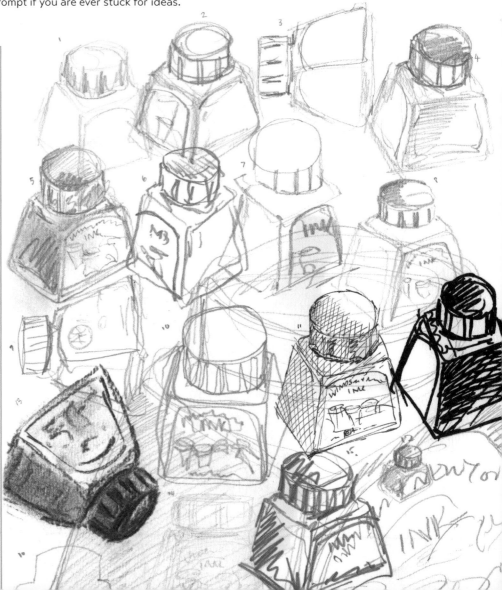

CONTINUOUS LINE DRAWING

A continuous line drawing is where you put the pencil or pen onto the page and don't lift it off at all until your sketch is finished. It's like one long strand of spaghetti!

INSTRUCTIONS

The instructions below will guide you through what to draw: you will be sketching a small object several times on a single sheet of paper. Use a stopwatch to time each exercise to keep you moving on to the next part quickly.

1. [*30 secs*] Make a very quick pencil sketch of your object anywhere on the paper using an **HB pencil**.

2. [*30 secs*] Turn the object. Make a very quick pencil sketch anywhere on the paper using a **2B pencil**.

3. [*30 secs*] Turn the object again. Make a very quick pencil sketch using a **4B pencil**.

4. [*1 min*] Turn the object once more. Make another pencil sketch of your object anywhere on the paper using the **2B pencil**.

5. [*2 mins*] Turn the object. Make another pencil sketch using the **2B pencil**.

6. [*1 min*] Turn the object. Put the **2B pencil** in your non-dominant hand (your left if you are right-handed) and sketch the object.

7. [*1 min*] Turn the object. Move the **2B pencil** back to your dominant hand and make a blind contour drawing (see pages 40–41).

8. [*1 min*] Remove the object from view, and draw it from memory with the **2B pencil**.

9. [*1 min*] Bring the object back to your line of sight. Hold the **2B pencil** at its very top so that you have less control and draw again.

10. [*1 min*] Turn the object. Make a continuous line drawing in **2B pencil** (see tip, above).

11. [*1 min*] Turn the object and draw it using a **fine-liner pen**.

12. [*1 min*] Turn the object and draw it with a **chunky marker pen**.

13. [*1 min*] Turn the object and draw it in **charcoal**.

14. [*1 min*] Turn the object and draw it in a very light line using the **2B pencil**.

15. [*1 min*] Turn the object and draw it using a very angry or strong line, using the **2B pencil**.

16. [*1 min*] Turn the object and draw its outline in **2B pencil**. Repeat the outline three or four times without looking at the object, just at the previous outline.

17. [*1 min*] Draw the object as small as you can on your paper using the **2B pencil**.

18. [*1 min*] Finally, draw the object as large as you can on your paper in **2B pencil**. It is likely you will have to draw over your previous sketches.

6. COLOUR PLAY

In this warm-up, we are going to become more familiar with colour and its wonderful possibilities; truly understanding the colours that you own is essential to be able to use them well. Understanding colour helps us to make better choices, and to appreciate why some colour combinations work so well and others simply don't.

This warm-up has three parts. I suggest doing each as a separate exercise at a different time. I often return to these exercises when I buy new paints and want to create a comprehensive reference guide of what they do.

1. CREATE YOUR OWN COLOUR WHEEL

The three primary colours (colours that cannot be created through the mixing of other colours) are red (or magenta), yellow and blue. When these are mixed together, two at a time, they become secondary colours: red and yellow make orange; yellow and blue make green; blue and red make purple (violet). A mixture of all three primaries results in black.

In this exercise, we are going to create a colour wheel of 12 hues created from just the three primary colours. It is a useful skill to be able to blend the exact colour that you want to use for a piece; it also means that you can limit the amount of paint you buy.

TOOLS & MATERIALS

· Paintbrush
· Good-quality paper – I used
 250gsm (140lb)
· Red/magenta, yellow and blue paints
 (I used acrylics)
· Pair of compasses (or a round object to
 draw a circle around)
· Pencil

INSTRUCTIONS

1. Draw a circle on your sketchbook page or paper.
2. Divide this circle up into roughly 12 sections.
3. In one section, paint some magenta straight from the tube or pan.
4. Skip three sections and then paint your yellow.
5. Skip three sections and then paint your blue.
6. Mix equal parts red (or magenta) and yellow to make an orange; paint this between the magenta and the yellow.
7. Mix equal parts blue and yellow to make a green; paint this between the yellow and blue you have already painted.
8. Mix equal parts red (or magenta) and blue to make violet; paint this between the magenta and blue you have already painted.
9. Paint a red, adjacent to the magenta section. Then fill in any more gaps by mixing primary colours with the secondary ones – mix red or magenta with the orange you have created to make an orangey-red or mix blue with green to make a bluey-green.

You have just created your own, simple 12-hue colour wheel.

Primary colours
(magenta, blue and yellow)

Secondary colours

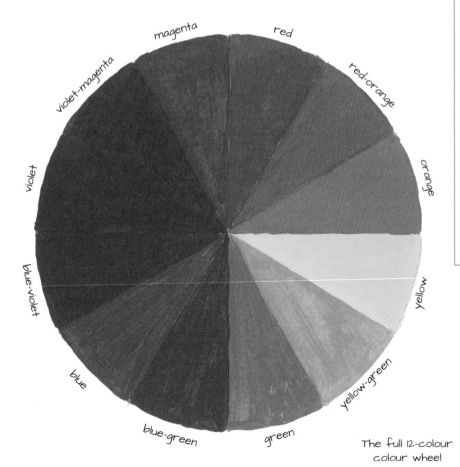

magenta

red

violet-magenta

red-orange

violet

orange

blue-violet

yellow

blue

yellow-green

blue-green

green

The full 12-colour
colour wheel

HANDY NOTES ON YOUR COLOUR WHEEL

Colour temperature Some colours are classed as warm and some as cool. For example, red and orange are commonly classed as warm colours, and blue and green as cool. In a painting or coloured sketch, temperature could have an influence on the feel of a piece. (See pages 84–85.)

Complementary colours These sit opposite each other on the colour wheel – red (magenta) and green, for example.

Analogous or harmonious colours These colours sit next to each other on the colour wheel – for example, red and orange.

Triadic These colours are evenly spaced from each other on the colour wheel – such as red, yellow and blue.

Split complementary (Stay with me here!) A split complementary is one colour along with the two colours adjacent to its complementary on the colour wheel: for example, red, blue-green and yellow-green – that is, red, plus the two colours on either side of green, which is the complementary of red.

SUSAN SAYS

You can achieve a more complex colour wheel by introducing tertiary colours. This is where a final hue (colour) is created from a blend of all three primary colours: red, blue and yellow are all included, in different amounts. What happens, for example, if you add a little blue into orange (which is a mix of yellow and red)?

45

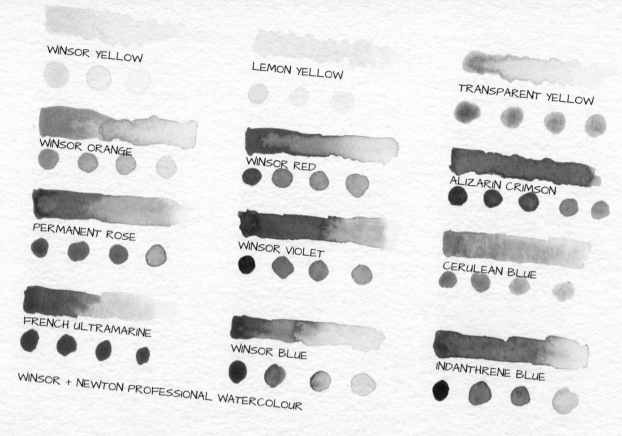

WINSOR YELLOW

LEMON YELLOW

TRANSPARENT YELLOW

WINSOR ORANGE

WINSOR RED

ALIZARIN CRIMSON

PERMANENT ROSE

WINSOR VIOLET

CERULEAN BLUE

FRENCH ULTRAMARINE

WINSOR BLUE

INDANTHRENE BLUE

WINSOR + NEWTON PROFESSIONAL WATERCOLOUR

2. SIMPLE COLOUR SWATCHES

This is an exercise that I do with all my new paints, whether they are watercolour, acrylic, gouache or anything in between.

TOOLS & MATERIALS

· Selection of paints
· Sketchbook page (thick, 200–300gsm / 110–140lb paper recommended)
· Paintbrush
· Jar of water
· Pencil

INSTRUCTIONS

1. With one of your colours, make a small swatch. This could be in a grid marked out with pencil or simply applied as a blob of paint to the page. If you are working with watercolour, you may like to mix the paint with lots of water (so the swatch is transparent), or less water (so it is highly pigmented), and mix some gradients in between.
2. Make a note in pencil near the swatch of the paint and colour you have used.
3. Make swatches across the page of all the paints you are testing that day.

You now have a handy reference for what the colours look like on paper when used straight out of the tube or pan.

3. TINTS AND SHADES

A tint occurs when you add white to a base colour; a shade occurs when you add black to a base colour. In this exercise, we are going to explore tinting and shading.

TOOLS & MATERIALS

· Range of paintbrushes
· Thick watercolour or mixed-media paper, or a sketchbook – 200–300gsm (110–140lb) paper is recommended as it won't buckle or warp when the wet paint is applied
· Pot of water
· Range of paints to explore, such as acrylic or gouache, including black and white
· Paint palette (or plate/plastic tray)
· Pencil
· Ruler

INSTRUCTIONS

1. Prepare your grid for painting: I used 5cm- (2in-) wide columns with five 2cm- (¾in-) high rectangles marked on, using pencil.
2. Start by choosing a base colour of gouache or acrylic paint and apply this to the central rectangle.
3. Put some white paint onto your palette and mix a little with your base colour. Apply this slightly lighter tint to the rectangle above the base colour.
4. Mix some more white in so the tint is much lighter and apply this third colour to the top section on your paper.
5. Clean your brush and then put some black paint on your palette. Mix a small amount of black into your base colour. Remember that the black is very strong so you often need less than you think. Paint this new, darker shade underneath the base colour rectangle.
6. Mix more black into the base colour to create the darkest shade. Apply this to the lowest (and final) rectangle on your paper strip. Wash your brush and paint palette.
7. Underneath each colour, write its name (as written on the tube) and any other details you find helpful: I usually note the type of paint (gouache or acrylic), the brand, how opaque the paint is, and how permanent it is (this information is usually provided on the label).
8. Leave this strip to dry and go again with another colour.
9. Keep going until all your colours are complete.

You now have a handy colour guide for all the tints and shades of your paints to refer back to when choosing colours for a project. Plus, hopefully you now understand what happens to each of your colours when black and white are added in differing amounts.

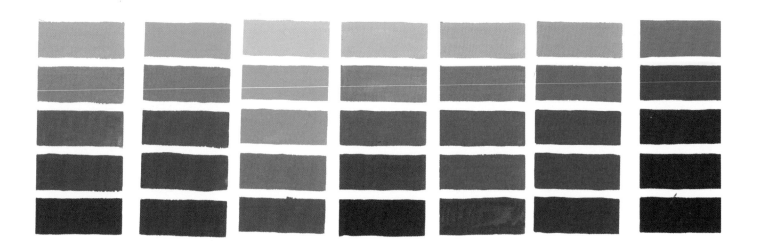

SEVEN DAYS OF SKETCHING

100 days of sketching in a row is a *big* task to undertake unless you already have a sketching habit established. So, why not set yourself an initial target of drawing for seven days in a row and see how you get on? A shorter time period in which to focus on getting your daily habit up and running is a great start, and will help you to build your confidence. Any long challenge, whether it is 30, 100 or a whole 365 days, has to start with the first week.

Whether you select seven random prompts from this book, choose one prompt and repeat it for seven days, or follow some of the special bonus challenges on this page – progressing to the 10-day challenge opposite – the choice is yours.

I recommend, though, that you decide in advance what your plan is, so that you will know exactly what you will be drawing before you open your sketchbook. This makes it all a little easier.

SEVEN-DAY CHALLENGES

Here are a few, shorter, seven-day challenges for you to try. These are all themed around different topics.

FLORAL

Day 1: Gerbera or daisy
Day 2: Rose
Day 3: Poppy
Day 4: Wildflowers or weeds
Day 5: Orchid
Day 6: A yellow flower
Day 7: Peony

AROUND THE HOUSE

Day 1: Bathroom
Day 2: Kitchen
Day 3: Living room
Day 4: Dining room
Day 5: The garage
Day 6: The study
Day 7: The garden

COLOURS

Day 1: Red
Day 2: Orange
Day 3: Yellow
Day 4: Green
Day 5: Blue
Day 6: Indigo
Day 7: Violet

ANIMALS

Day 1: Cat
Day 2: Elephant
Day 3: Lizard or snake
Day 4: Rabbit
Day 5: Lion
Day 6: Mouse
Day 7: Deer

10-DAY EVERYDAY OBJECTS CHALLENGE

Day 1: Cups and mugs

Day 2: Pens

Day 3: Wires, cables and plugs

Day 4: Toothbrush

Day 5: Rubbish

Day 6: A packet of...

Day 7: Bits and bobs

Day 8: Kitchen utensils

Day 9: Something left on the floor

Day 10: Cupboard under the sink

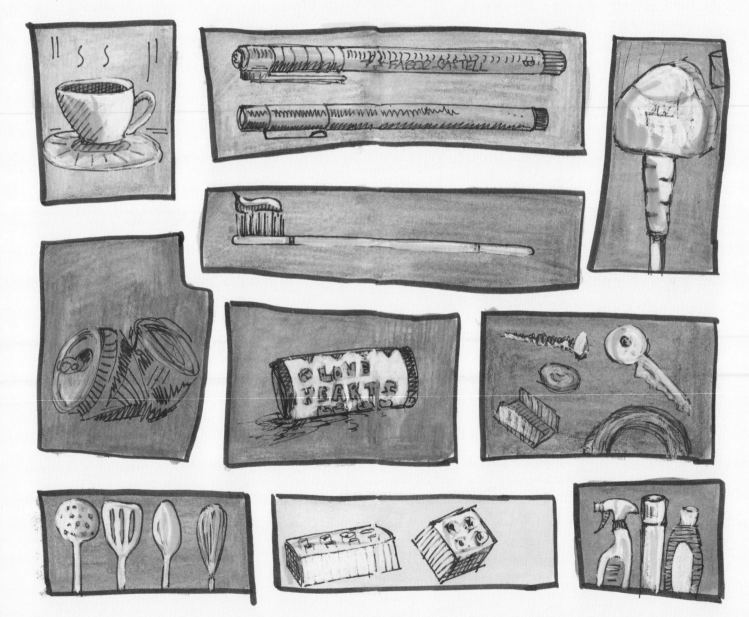

SKETCHING PROMPTS

This section of the book contains your 100 sketching prompts: words, phrases, objects and ideas for you to use as starting points for sketching. There is huge variety in these prompts and although many are simple to approach, others may prove more of a challenge.

STRAIGHTFORWARD SKETCHING PROMPTS

Every prompt in this book is designed to be achievable for artists of all types and abilities. The prompts are straightforward, often self-explanatory and, hopefully, will allow you to complete a sketch in just a few minutes. Aim to keep to short timescales initially, to achieve a sketch on a daily basis, and build up from there.

What you will *not* find among these prompts are abstract concepts, emotions or very complex subjects. I have stopped many drawing challenges after a few days when the prompts were too difficult – you don't want to have to think too much before sketching – one thing that can put anyone off sketching – one thing that can put anyone off

drawing is having to use the logical side of the brain before the creative side. On the other hand, if the prompt is 'leaf', we can quickly and easily find a leaf, or picture of a leaf, and get going.

The prompts in this book are literal, if you want them to be, but the more experienced or confident artist can choose to take them further. Using the 'leaf' prompt example again, a beginner may pick a leaf from a tree and sketch it; a more experienced artist may draw the whole tree or interpret the prompt by drawing the leaf of a book instead. It is always easier to get creative with a straightforward prompt than to simplify something complex.

SEEKING INSPIRATION

When it comes to sketching, many of us need a subject in front of us from which to draw. I personally find it very hard to draw from my imagination, unless I am drawing something abstract or fantastical. So here are a few suggestions on where to seek inspiration and reference, in my order of preference.

I encourage you to sketch from **real life** as much as you can – the objects, people or scenes right in front of you. If the prompt is 'flower', I advise that you find a real flower as inspiration. Sketching from life encourages you to *really* look at a subject in its true form. You can choose your viewpoint – look at the flower from above or at eye-level; you can see the colours as they are, and you can move the object closer to you, to view its details.

After real life, I recommend using **your own photographs**. This is especially handy if you don't have the subject close by, but have taken photographs in the past – for example, if you want to draw people walking, a photograph captures the moment so that you can take your time with your sketch.

The last point of reference is **other people's photographs**, **illustrations from books** or **images on the internet**. For me, these are a last resort, as these images may be copyrighted, and it is not always appropriate to copy someone else's photograph or artwork. However, sourcing other people's images as inspiration or reference may be a more practical option for some of the prompts – if the prompt is 'under the sea,' it is highly unlikely that you will be able to draw a scene from life!

SUSAN SAYS
Create an 'inspiration' folder on your phone, camera or tablet device. Start gathering photographs of things that interest you when you are out and about.

A NOTE ON ORIGINALITY AND COPYRIGHT

Studying other artists' work and replicating it in a sketchbook is a traditional method of learning, and of understanding art. However, it is important to understand that you cannot copy another artist's work or source photograph and pass the image off as your own. There is a big difference between making a sketch for personal use, and copying a work and selling it for profit.

1 PATTERN

Patterns are a wonderful way to fill a sketchbook – grab a pen, pencil or paintbrush, and fill a whole page with whatever designs come to mind. If this is the first time you have done something like this, keep it simple by using circles, lines, dots, dashes and other basic shapes repeated several times.

You may want to divide the page into sections and fill each section with a different pattern or simply repeat one pattern everywhere across the page. I love doing this as a warm-up exercise or when I have just five minutes to spare and want to sketch something easy. I have pages of pattern dotted across various sketchbooks that I am working on at the same time. Sometimes I just fill one little square and I'm done, sometimes I fill a whole page and sometimes I go crazy and add colour too!

SUSAN SAYS
A great way to create neat edges when working with paint, such as in the watercolour examples above, is to stick down low-tack artists' tape, washi tape (Japanese paper tape) or masking tape to create even sections on your page. You can then paint over the tape and when your sketch is complete, pull it off to reveal neat edges - which is very satisfying indeed.

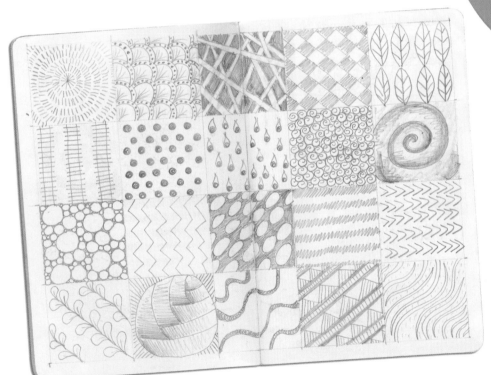

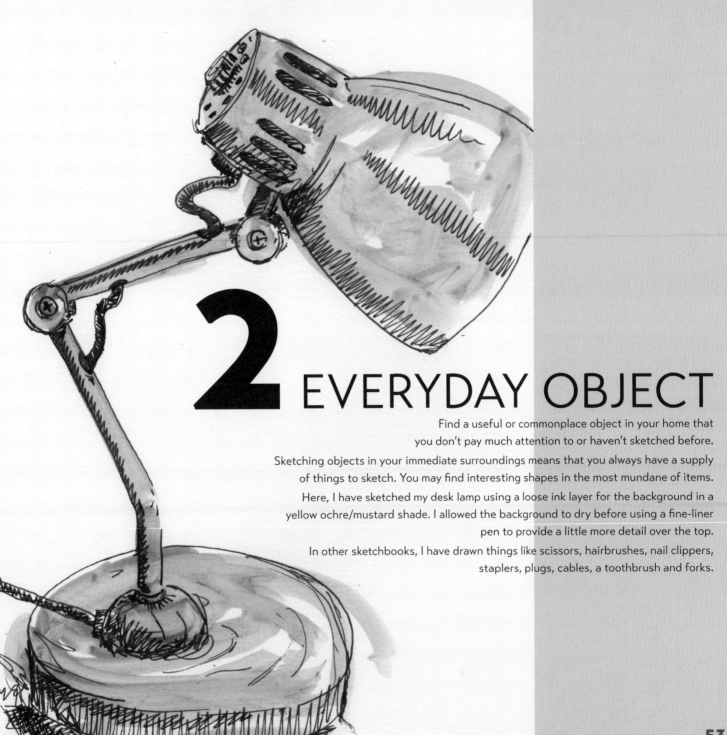

2 EVERYDAY OBJECT

Find a useful or commonplace object in your home that you don't pay much attention to or haven't sketched before.

Sketching objects in your immediate surroundings means that you always have a supply of things to sketch. You may find interesting shapes in the most mundane of items.

Here, I have sketched my desk lamp using a loose ink layer for the background in a yellow ochre/mustard shade. I allowed the background to dry before using a fine-liner pen to provide a little more detail over the top.

In other sketchbooks, I have drawn things like scissors, hairbrushes, nail clippers, staplers, plugs, cables, a toothbrush and forks.

3 LUNCH

What are you eating for lunch today? Let's sketch that sandwich or that bowl of soup. By sketching the food we eat, we have a subject available every day to draw. Enjoy your lunch (hopefully it won't be too cold by the time you come to eat it!).

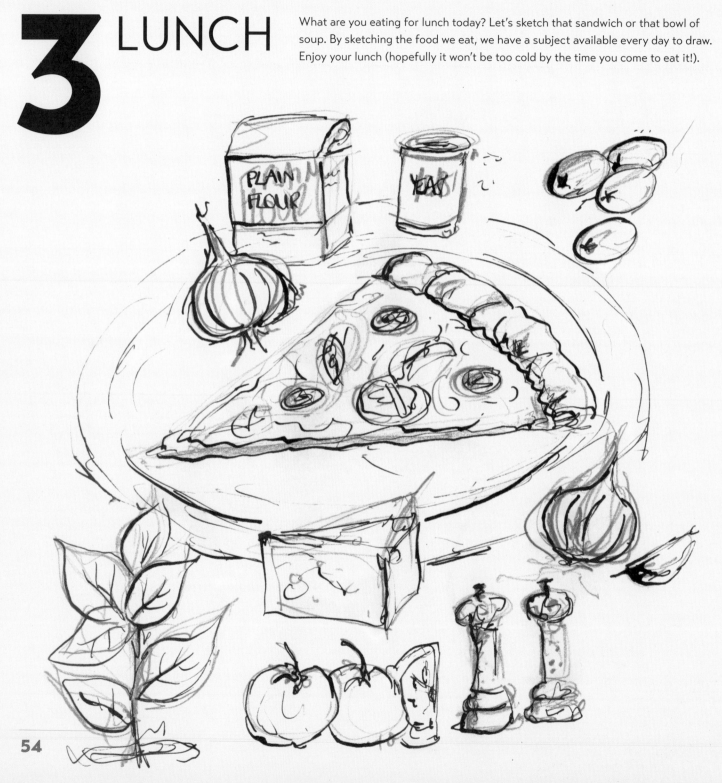

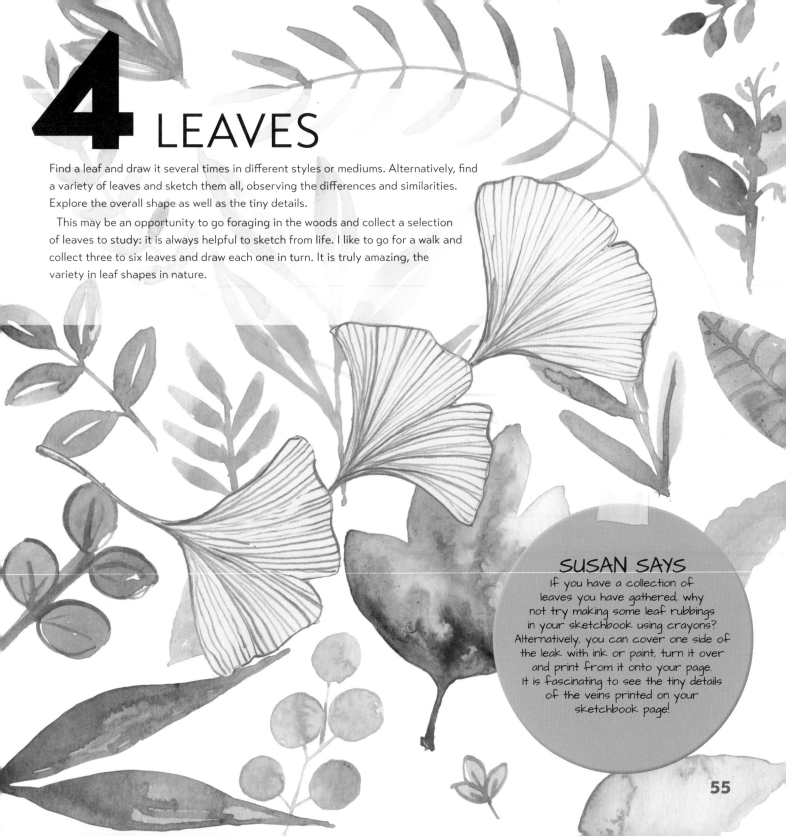

4 LEAVES

Find a leaf and draw it several times in different styles or mediums. Alternatively, find a variety of leaves and sketch them all, observing the differences and similarities. Explore the overall shape as well as the tiny details.

This may be an opportunity to go foraging in the woods and collect a selection of leaves to study: it is always helpful to sketch from life. I like to go for a walk and collect three to six leaves and draw each one in turn. It is truly amazing, the variety in leaf shapes in nature.

SUSAN SAYS

If you have a collection of leaves you have gathered, why not try making some leaf rubbings in your sketchbook using crayons? Alternatively, you can cover one side of the leak with ink or paint, turn it over and print from it onto your page. It is fascinating to see the tiny details of the veins printed on your sketchbook page!

5 BOXES

Sketching boxes is the perfect opportunity to explore how to draw three-dimensional shapes – specifically cubes. Try drawing a box following the simple steps below. Once you have depicted the three-dimensional structure of a box, you can then add any details you see on the surface.

1. Draw a square.

2. Draw a second square, behind the first, and offset to the side.

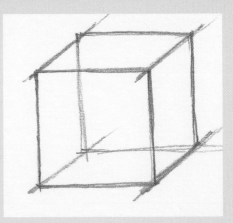

3. Connect the corners of the two squares with diagonal lines.

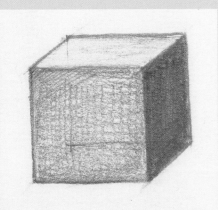

4. Strengthen the lines and tidy up any unwanted marks. Add some shading, one side light, one a mid-tone dark.

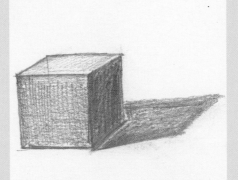

5. Add a shadow. Consider where your light source is. Your shadow will fall on the darkest side.

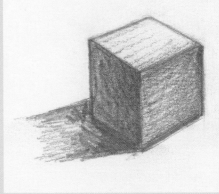

6. You can now play with rotating the box and creating shadow in different directions.

6 WINDOWS AND DOORS

Draw what you see through a window or draw the window itself. I like looking at the shapes of windows and doors and doodling them in a fine-liner pen or a pencil.

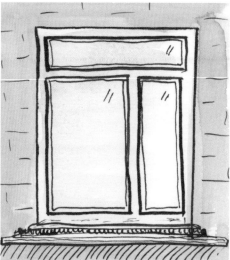

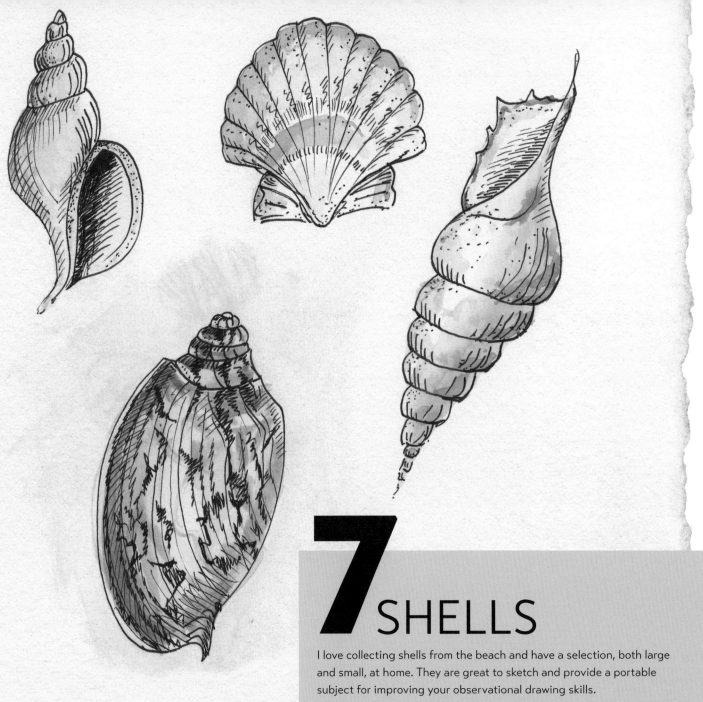

7 SHELLS

I love collecting shells from the beach and have a selection, both large and small, at home. They are great to sketch and provide a portable subject for improving your observational drawing skills.

Don't forget that, if you don't have any shells to hand, you can look at photographs, images on the internet or in books for reference.

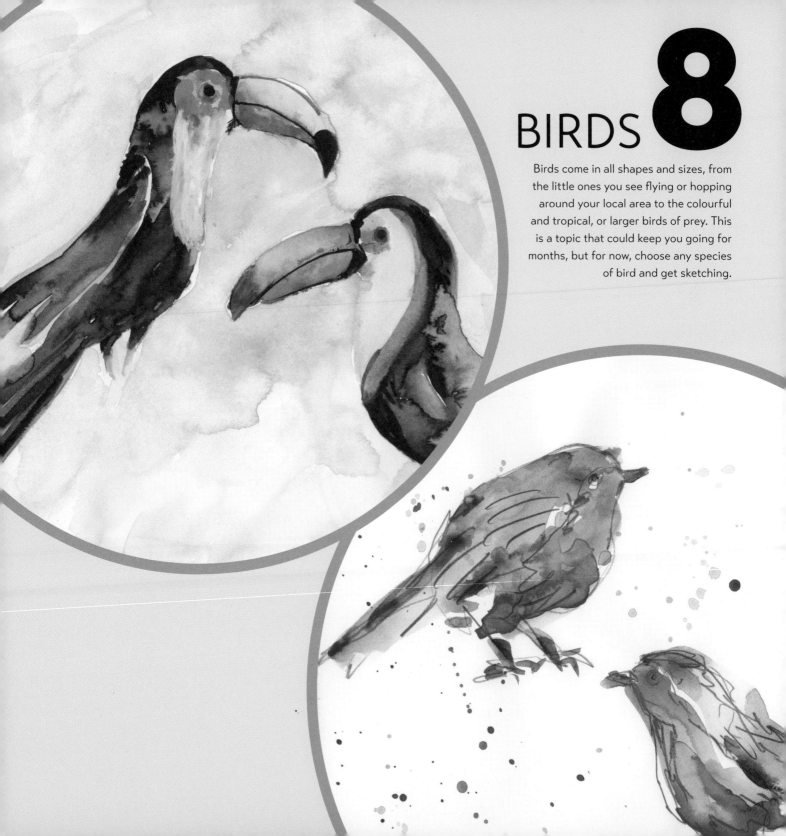

BIRDS 8

Birds come in all shapes and sizes, from the little ones you see flying or hopping around your local area to the colourful and tropical, or larger birds of prey. This is a topic that could keep you going for months, but for now, choose any species of bird and get sketching.

9 PICK A COLOUR

I love choosing a colour as a starting point, and, each year when I am running my annual Sketchbook Challenge, I choose a colour for one of the prompts.

So, pick a colour, and get sketching. You may wish to choose your favourite colour, one you don't use that often, or work your way around a colour wheel. (See pages 44–45 for information on colour theory.)

Once you have chosen your colour, wander round your home and look for things of that colour – you will be amazed at all the shades of colour you will find. Look for at least 10 objects or items, then get sketching.

I also love sketching things in the 'wrong' colour, like this cactus (right) that I sketched in dark blue and indigo. It can be great fun to sketch or paint something in a colour you like but isn't the actual colour of the item.

SUSAN SAYS
I love creating collections of identically-coloured objects and photographing them as inspiration. I go around my home and studio and collect as many things as I can find in my chosen colour. I then lay out the items on the floor or a table and take a photograph of them all together.

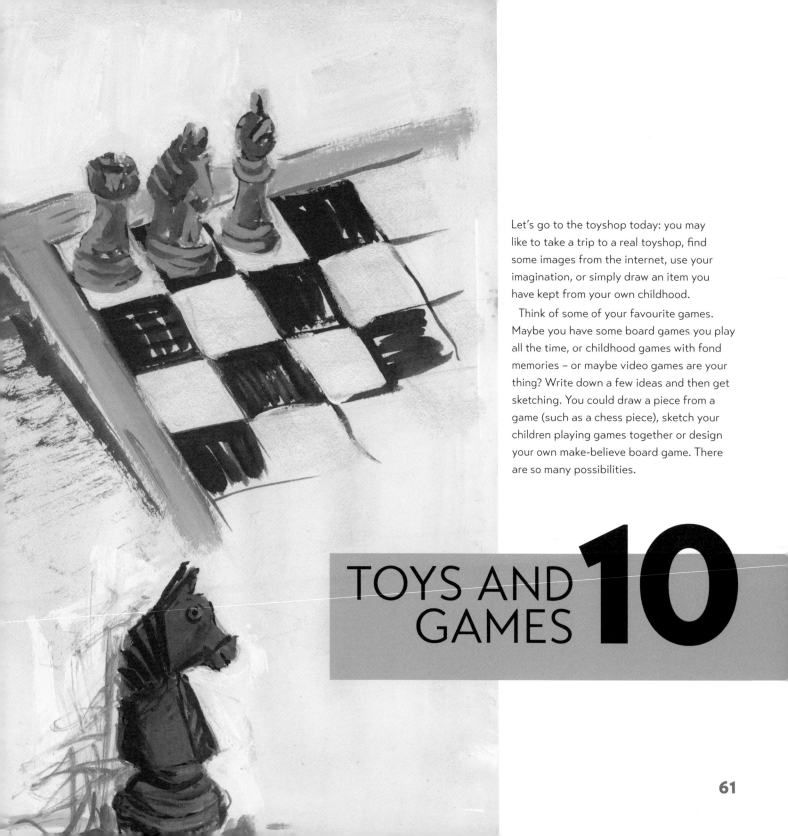

Let's go to the toyshop today: you may like to take a trip to a real toyshop, find some images from the internet, use your imagination, or simply draw an item you have kept from your own childhood.

Think of some of your favourite games. Maybe you have some board games you play all the time, or childhood games with fond memories – or maybe video games are your thing? Write down a few ideas and then get sketching. You could draw a piece from a game (such as a chess piece), sketch your children playing games together or design your own make-believe board game. There are so many possibilities.

TOYS AND GAMES 10

11 PENS AND PENCILS

Let's sketch the things we sketch with – our pencils and pens. Maybe arrange them on your desk or place them in a pot, and draw. You could even use this prompt alongside the warm-up exercise, 'Small object observation', on pages 42–43.

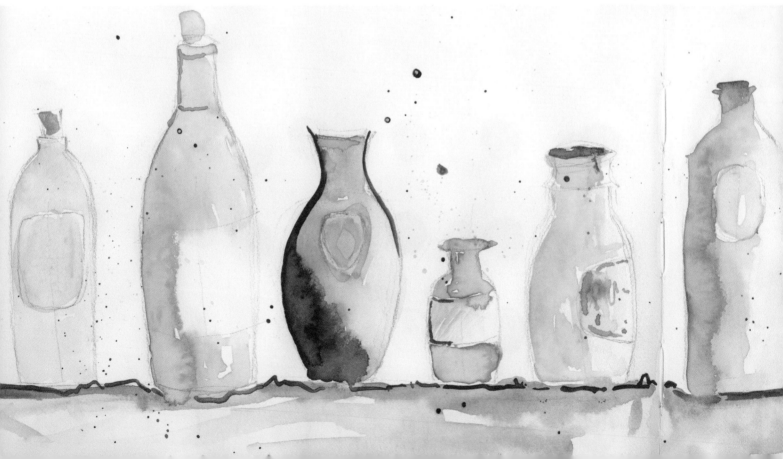

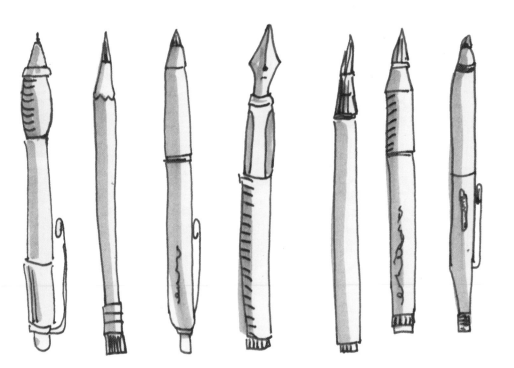

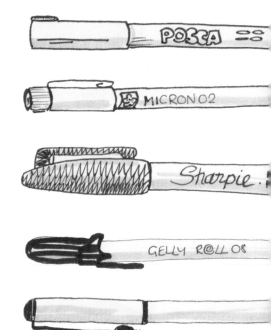

POSCA

MICRON 02

Sharpie.

GELLY R@LL 08

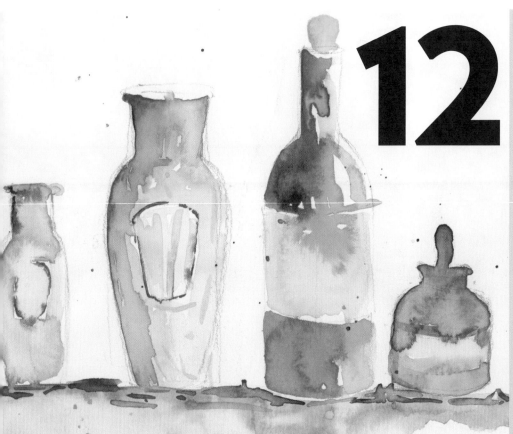

12 BOTTLES

There are so many interesting shapes and sizes of bottle that you could choose to sketch for this prompt. I'm sure that you have a number of bottles readily available in your home.

Here are some suggestions of ways to tackle this prompt:

- Take your time and do a detailed pencil study of a single bottle;
- Maybe use today as the opportunity to draw something transparent;
- Study the labels you find on the fronts of bottles;
- Sketch some small thumbnails of bottle shapes that you find around your home;
- Draw some bottle shapes from your imagination.

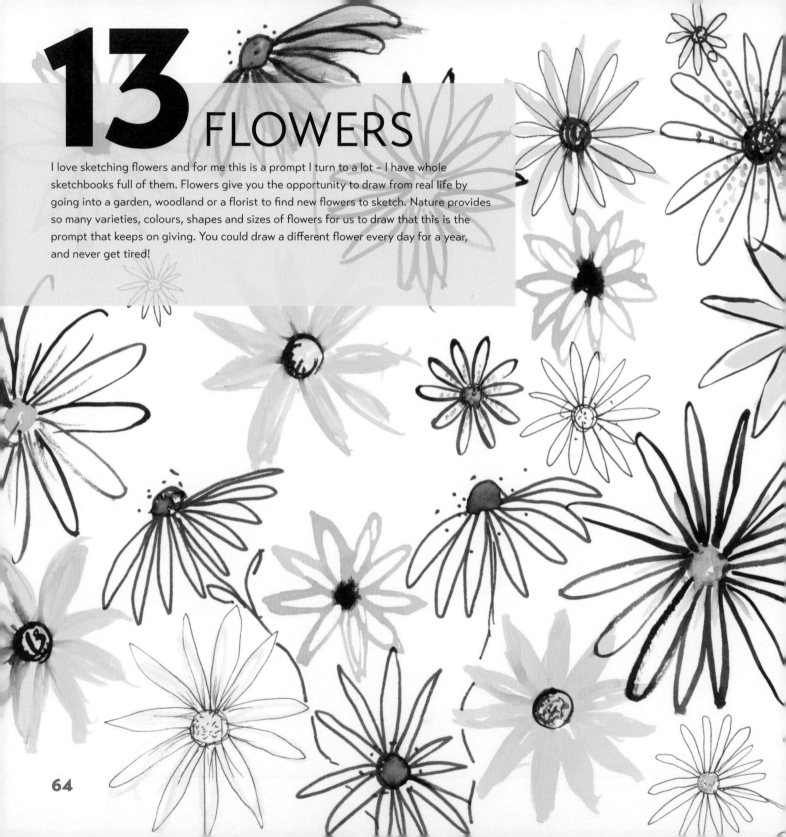

13 FLOWERS

I love sketching flowers and for me this is a prompt I turn to a lot – I have whole sketchbooks full of them. Flowers give you the opportunity to draw from real life by going into a garden, woodland or a florist to find new flowers to sketch. Nature provides so many varieties, colours, shapes and sizes of flowers for us to draw that this is the prompt that keeps on giving. You could draw a different flower every day for a year, and never get tired!

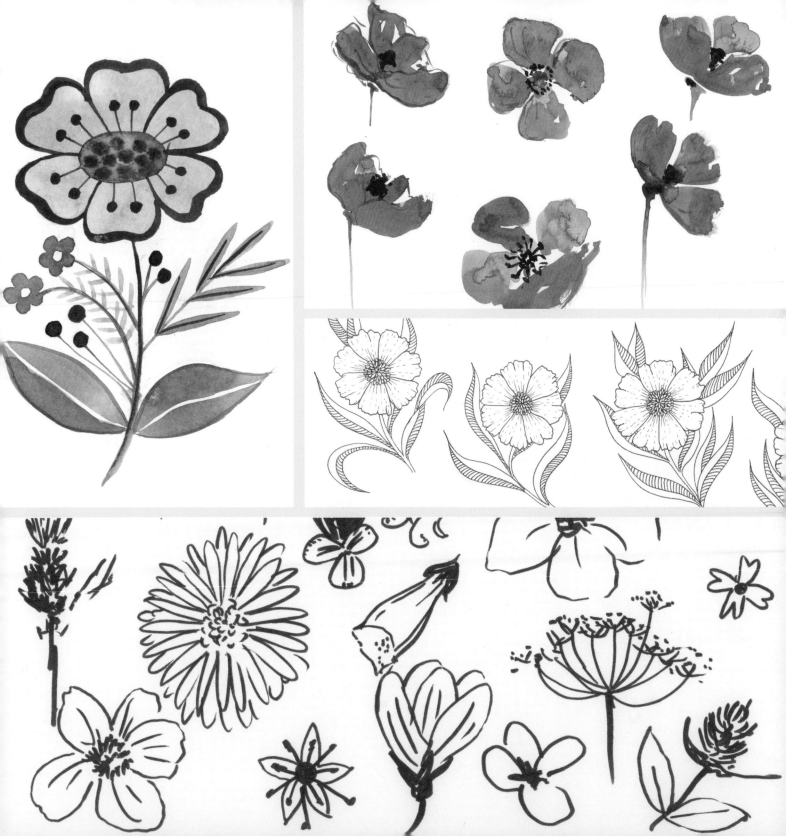

14 KITCHEN UTENSILS

There are many interesting utensils found in the kitchen from the humble wooden spoon to spatulas, mashers, whisks and other curious objects. Draw a single utensil or a whole selection *in situ*.

For the design here, I used a black felt-tip pen and drew one continuous line across the page to create the sketches. See page 43 for an explanation of continuous line drawing.

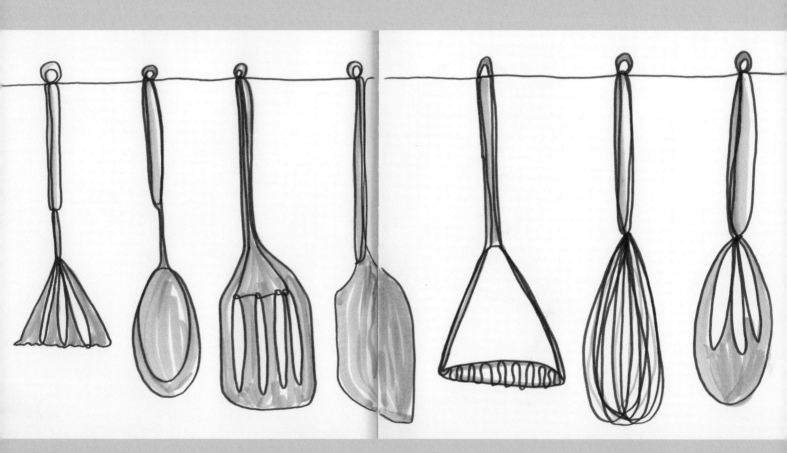

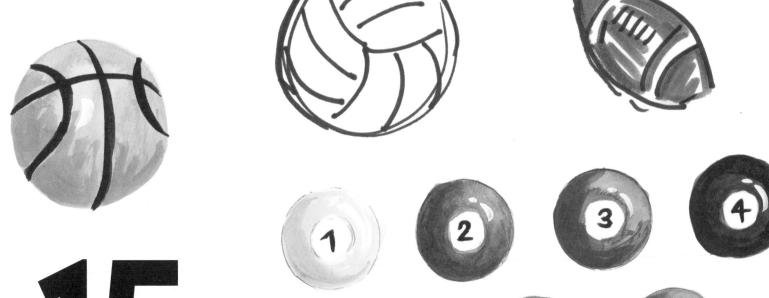

15 BALLS

Football, marble, golf ball, bauble, basketball, bouncy ball, gumball, snooker ball, cricket ball, ball pool... so many balls.

This is a great opportunity to depict and explore spheres, whether you choose one or a few. Study an individual ball or draw one in context – a football during a match or a snooker ball on the table. Look at how you can depict the three-dimensional quality of a sphere: its roundness, and any unique texture, colour or imperfection that a real ball would have.

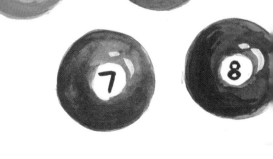

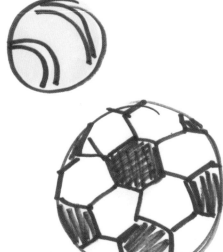

16 BUTTERFLIES AND MOTHS

There are so many wonderful species of butterfly and moth out there. You can either study an individual moth or butterfly that fascinates you, or make up your own design. Consider adding colour to your sketch as well.

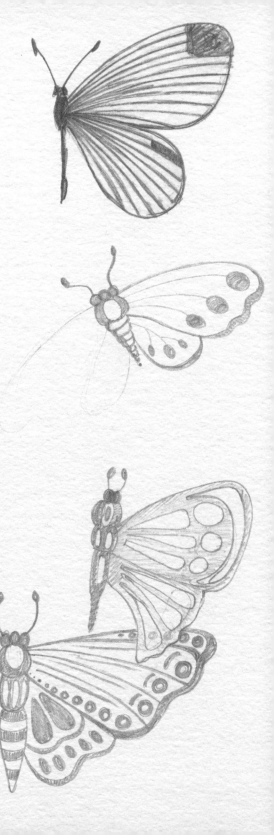

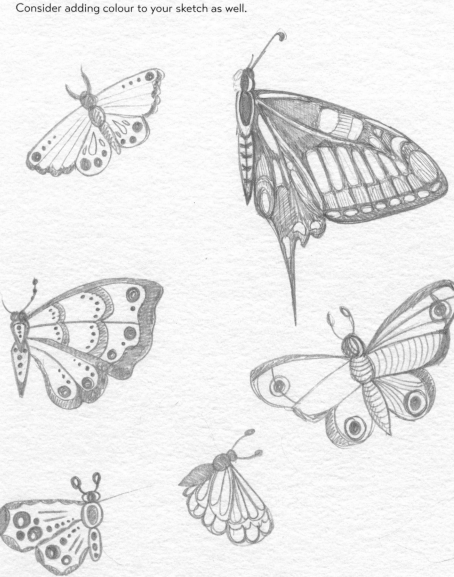

17 SPOTS AND DOTS

A simple subject today – the dot!

There are several ways to work with this prompt. You could explore spots and dots in the same way as the warm-up exercise, 'Mindful circles' (see page 35) – creating patterns on a page. Or you could find something around your home that has spots and dots on it, such as the fabric of your clothing or a tablecloth, cushion cover or shower curtain.

SUSAN SAYS

I like to play with this prompt by creating spots of colour using watercolour (as shown). To do this, I dot several small coloured circles in watercolour paint across my sketchbook page, varying the ratios of paint and water. For some circles, I use a 'wet-on-wet' technique, where I put down a circle of water and then drop a little pigment into it. For others I have added little details after the main colour has dried.

Look at using dots within a painting technique, such as pointillism - a style of painting wherein minute dots of colour are applied to a surface to create an image that is more clearly visible when you step back to view the painting in full.

18 SOMETHING BEGINNING WITH...

Selecting a letter as a starting point can be an unique way to get started with a sketch. I love to pick a letter from the alphabet and then find something that begins with that letter to draw... it's amazing where the mind takes us sometimes. Maybe create yourself a whole alphabet of sketches – you might find that this fills a whole sketchbook!

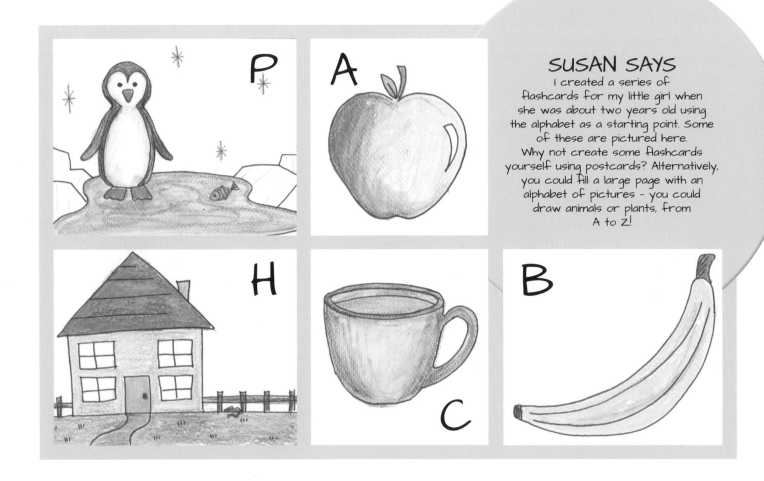

SUSAN SAYS
I created a series of flashcards for my little girl when she was about two years old using the alphabet as a starting point. Some of these are pictured here. Why not create some flashcards yourself using postcards? Alternatively, you could fill a large page with an alphabet of pictures - you could draw animals or plants, from A to Z!

19 TRANSPORT

Planes, trains and automobiles! Get drawing any type of transport that takes you from A to B. This can be a great opportunity to sketch while out and about, or to take some photographs to use as reference later on. You can draw your own car or bicycle, or any vehicle that you use to get around.

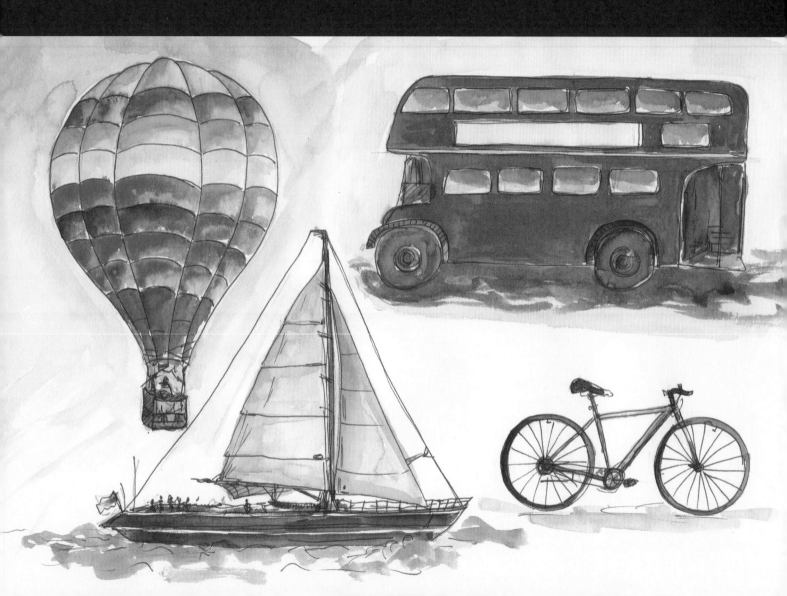

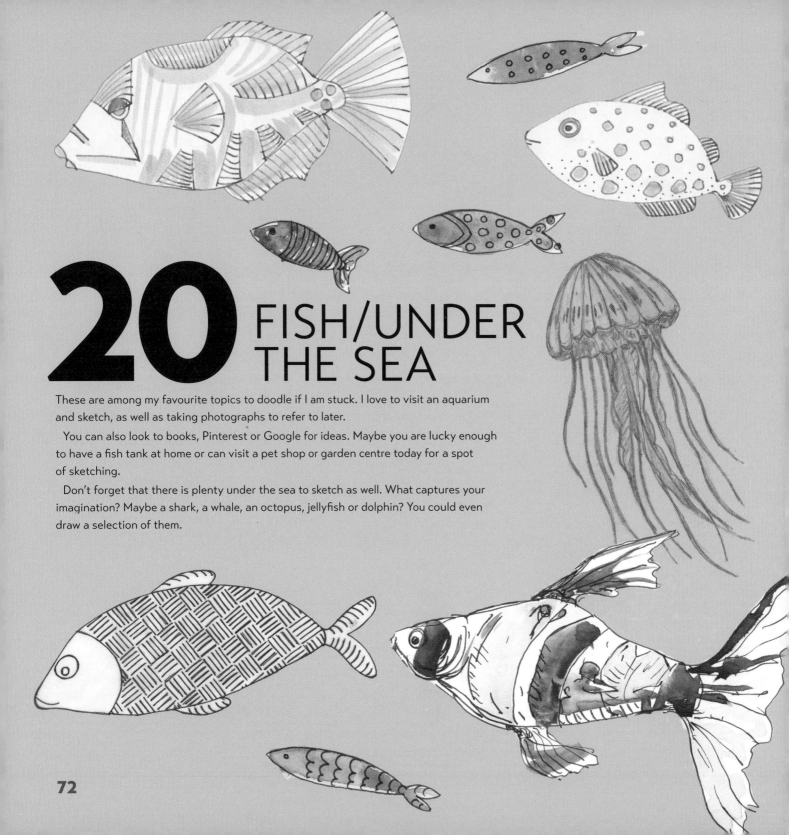

20 FISH/UNDER THE SEA

These are among my favourite topics to doodle if I am stuck. I love to visit an aquarium and sketch, as well as taking photographs to refer to later.

You can also look to books, Pinterest or Google for ideas. Maybe you are lucky enough to have a fish tank at home or can visit a pet shop or garden centre today for a spot of sketching.

Don't forget that there is plenty under the sea to sketch as well. What captures your imagination? Maybe a shark, a whale, an octopus, jellyfish or dolphin? You could even draw a selection of them.

21 VASES, JUGS AND CONTAINERS

Vases and containers are a traditional subject matter in still-life paintings and drawings (see also page 137). Vessels of all shapes and sizes are useful for practising your observational skills and depicting three-dimensional objects on the page. Look at the size, shape and material of the vessel you are drawing. Glass can be a real challenge to depict, for example, and for that reason can be a beneficial learning experience. Some vases and containers may have interesting patterns and designs on them. You may choose to sketch a selection of vases and containers of different shapes, or perhaps use your imagination to come up with some unique designs.

In the examples here, I used a soft pencil to create a range of basic shapes. I then used acrylic paint to add colour and detail. These were all five-to-ten-minute studies.

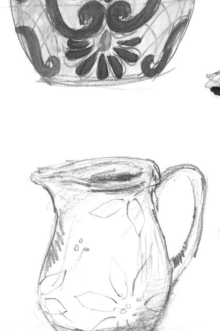

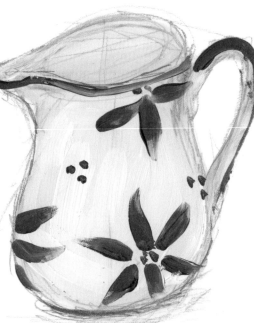

22 BUGS AND BEASTIES

Bugs, insects and creepy-crawlies are what we will sketch for this prompt. I have some lovely books that I refer to when drawing insects, but you can always draw from real life, photographs you have taken – or your imagination!

Draw a single beastie or a whole page of little bugs and have fun sketching these little critters.

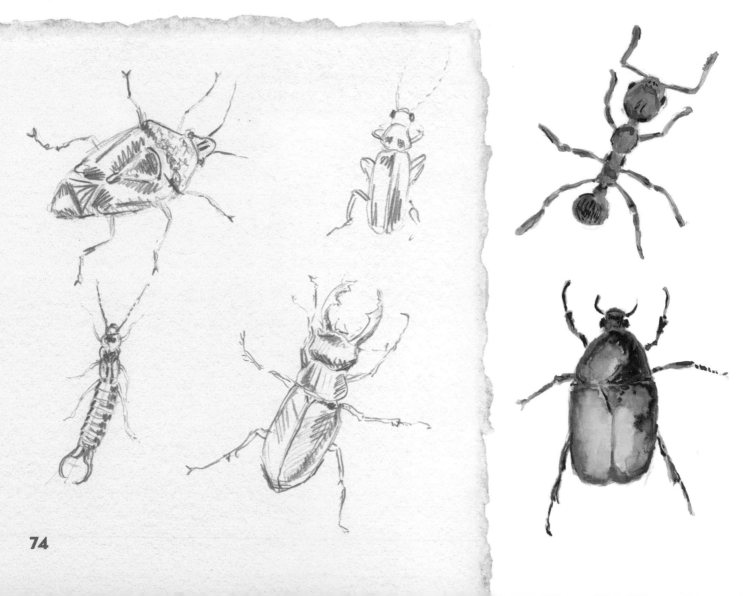

23 MUSHROOMS AND FUNGI

Time to explore the wonderful world of mushrooms and fungi. There are some truly interesting shapes and colours to be found, so, whether you sketch from real life or from pictures, enjoy drawing fungi today.

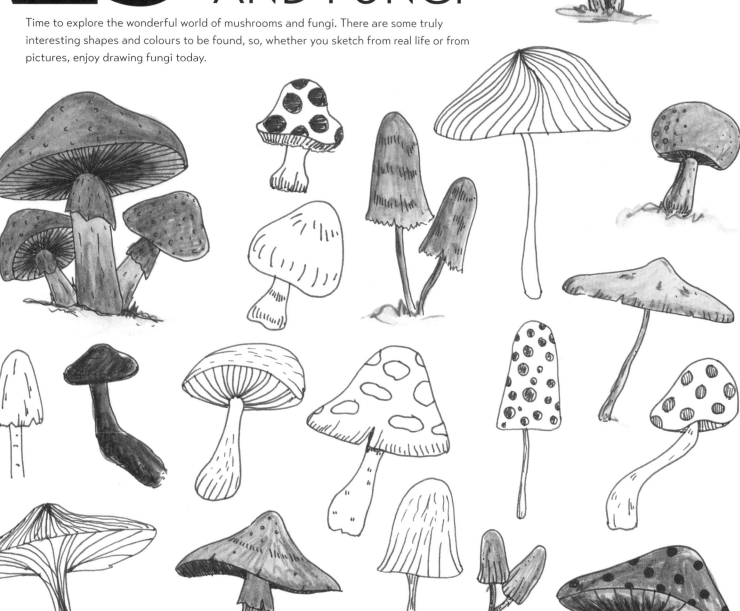

24
BAGS

Bags can be small or large, practical or stylish. Choose a bag that you find interesting in terms of its shape, colour and texture, and get sketching. Draw from different angles or complete a single study.

You could also empty out the contents of your bag and sketch those.

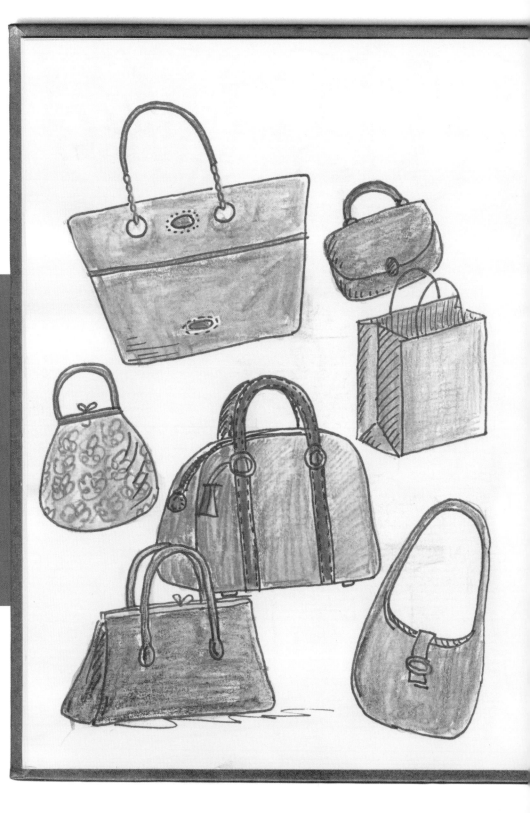

25 WATER

Water in a glass, water in a lake, water in the bath, water droplets or the sea. There are so many ways to explore this prompt, so choose a way that works for you and sketch some water in any way, shape or form.

The word 'water' automatically makes me think of watercolour paint, which uses a lot of water in its application. To create the images on this page, I sketched in pencil a series of cups and glasses and used a large watercolour paintbrush loaded only with water to fill them up. I then selected several blue watercolour paints and dropped a little pigment into the water on the page to see what happened. Sometimes I added more pigment, or more water to allow the paint to 'bloom', applying the wet-on-wet technique I described on page 69.

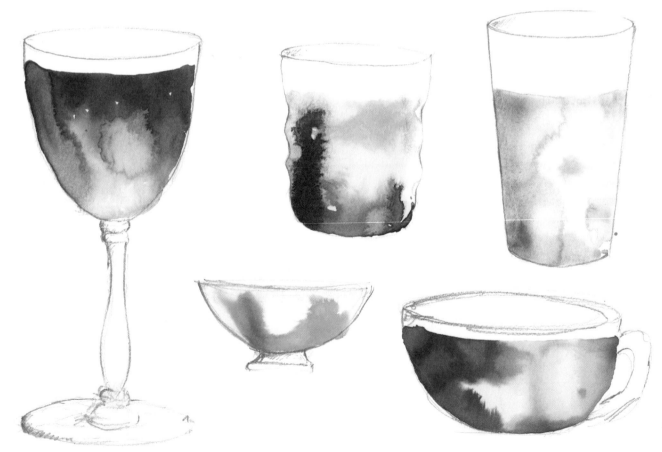

26 FRUIT AND VEG

Fruit and vegetables make a great prompt that has proven popular with my sketching students and Sketchbook Challengers in the past. You could sketch a single piece of fruit, or sketch a selection of vegetables from your kitchen.

Consider also where the fruit or vegetable is located – in a bowl on the table, at the greengrocers', in your fridge drawer or on the original tree or plant that it grew on.

I sketch this topic a lot and use a whole range of materials in my explorations. Across these two pages you can see a mixture of mediums including coloured pencil, pen and ink, gouache and watercolour.

SUSAN SAYS

Collage is a fantastic technique to use in a sketchbook. To create the images on the right, I painted sheets of paper in the colours of fruits using watercolour and gouache, cut them out into the appropriate fruit shapes and stuck them down in my sketchbook.

These pieces were inspired by the work of illustrator Eric Carle (1929-2021), who used collage in his work, including the famous children's book, *The Very Hungry Caterpillar*.

You can stick down any paper ephemera that you have collected and use it as a background to sketch onto. In addition, you can use smaller pieces of paper to make up a larger image. or cut out text from newspapers and magazines.

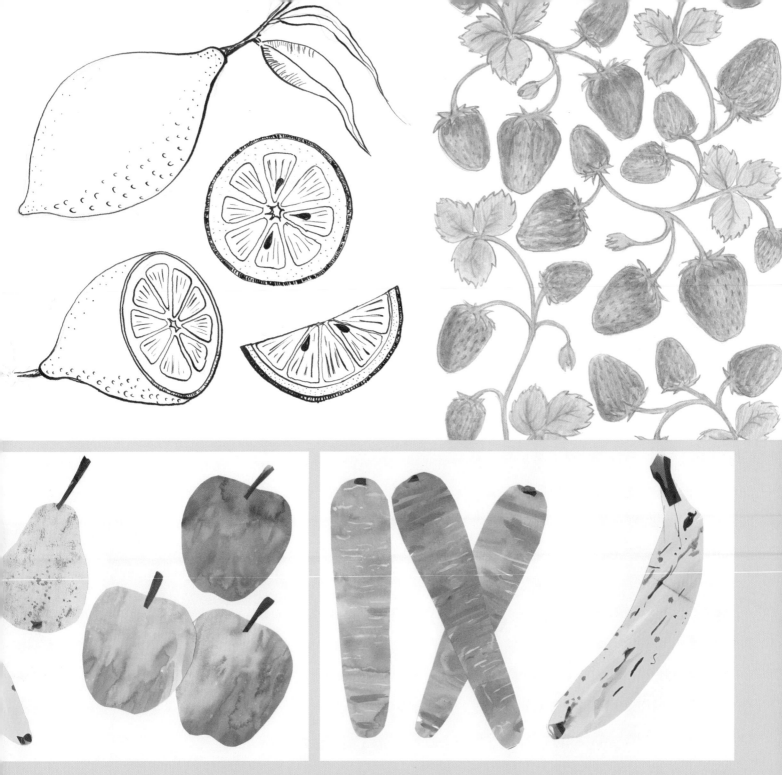

27 BUILDINGS

Buildings are all around us (you are probably in one now) and provide fabulous subject matter for sketching. Architecture is a vast topic, and there are countless styles and designs of buildings to choose from.

You can keep things simple by drawing your own home, your work building or the street in which you live. Drawing street scenes, urban sketches and cityscapes can be a wonderful way to appreciate perspective as well.

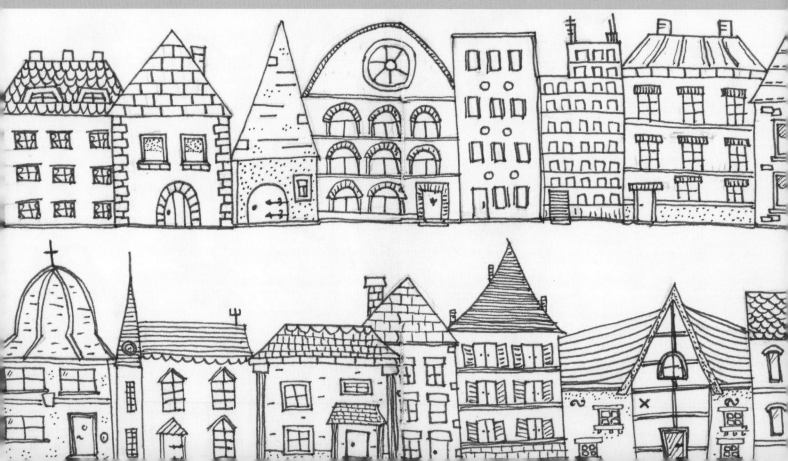

28 CLOCKS, WATCHES AND TIME

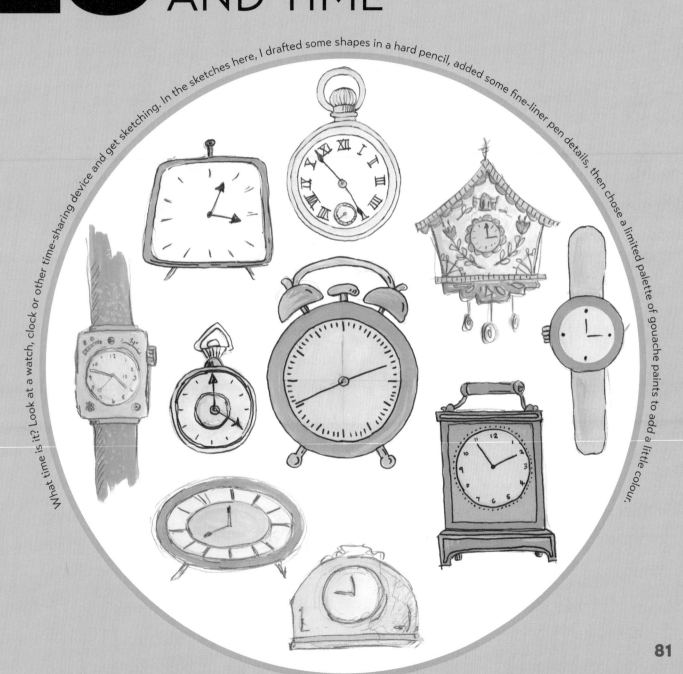

What time is it? Look at a watch, clock or other time-sharing device and get sketching. In the sketches here, I drafted some shapes in a hard pencil, added some fine-liner pen details, then chose a limited palette of gouache paints to add a little colour.

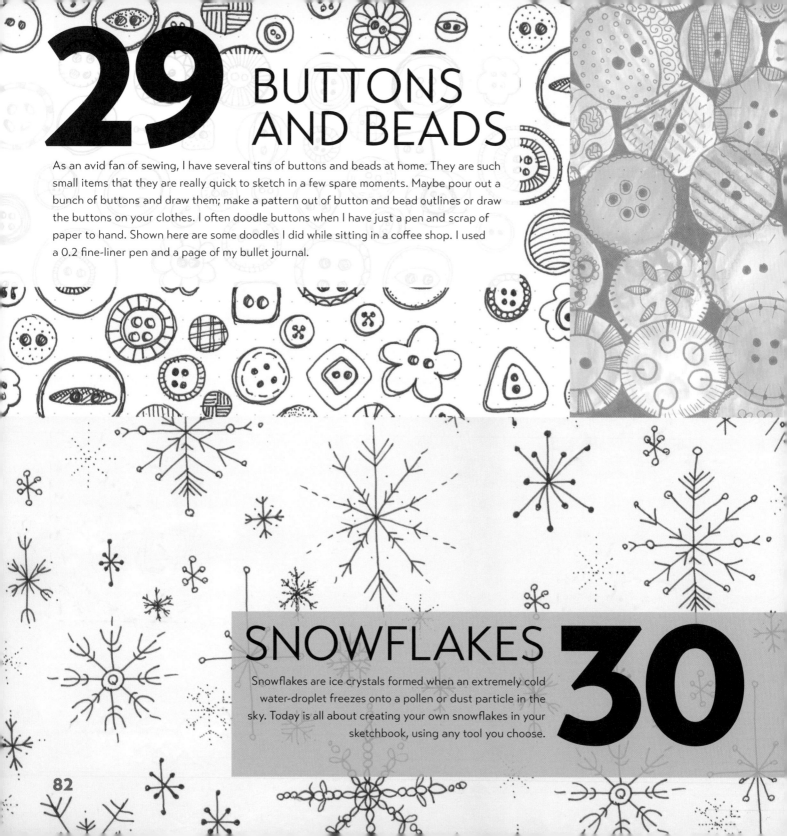

29 BUTTONS AND BEADS

As an avid fan of sewing, I have several tins of buttons and beads at home. They are such small items that they are really quick to sketch in a few spare moments. Maybe pour out a bunch of buttons and draw them; make a pattern out of button and bead outlines or draw the buttons on your clothes. I often doodle buttons when I have just a pen and scrap of paper to hand. Shown here are some doodles I did while sitting in a coffee shop. I used a 0.2 fine-liner pen and a page of my bullet journal.

SNOWFLAKES 30

Snowflakes are ice crystals formed when an extremely cold water-droplet freezes onto a pollen or dust particle in the sky. Today is all about creating your own snowflakes in your sketchbook, using any tool you choose.

31 GARDEN

I love my little garden and I find that in the summer, or any time that the weather is pleasant, it provides me with endless inspiration for sketching. From the flowers, trees and shrubs to the local wildlife, pots and gardening tools, there is always something there to draw.

Whether you have your own garden, access to a communal green space, a balcony, window box, or whether you visit a public garden, this can be an endless topic to explore.

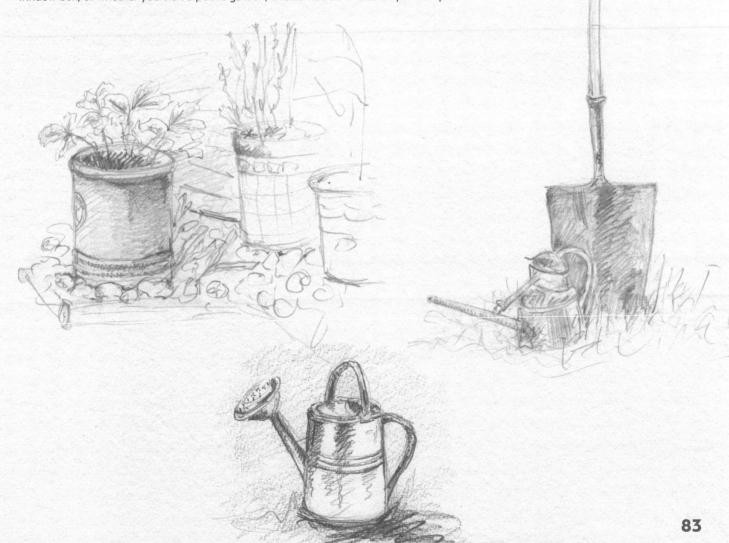

32 SOMETHING HOT

Today your task is to draw something inspired by the word 'hot'.

As a starting point, you could search around your home for things that generate heat or warmth and start sketching those items.

COLOUR TEMPERATURE

Colours can be said to have a temperature: warm colours typically being reds, oranges and yellow, and cool colours being on the opposite side of the colour wheel: the greens, blues and purples. Individual colours can also have a warm or a cool hue, depending on whether they have more yellow, red or blue in them. Warm colours have an association with heat (summer, the sun and fire) and cool colours with coldness (winter, ice and water).

Hot colours

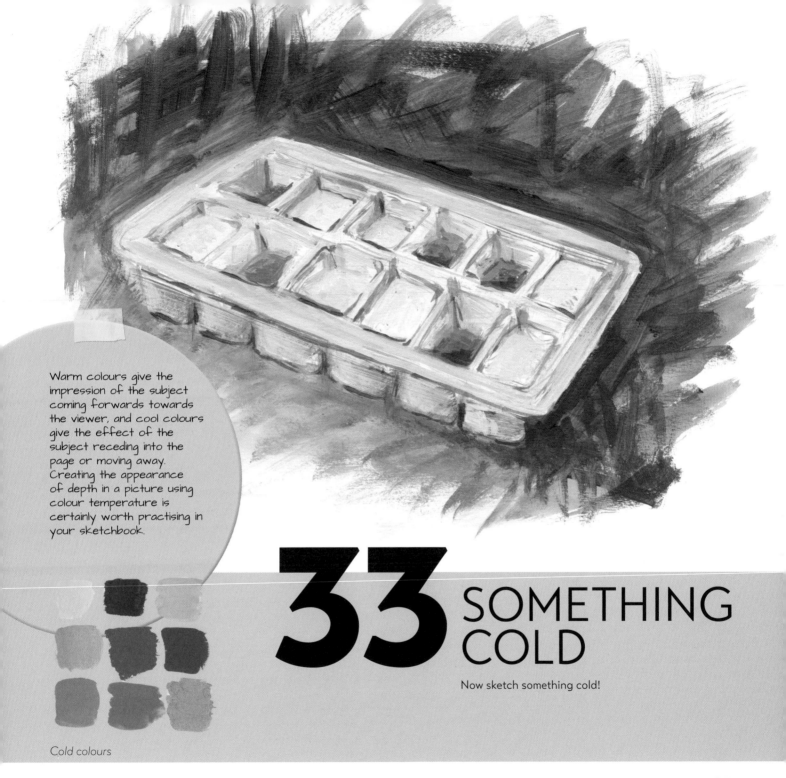

Warm colours give the impression of the subject coming forwards towards the viewer, and cool colours give the effect of the subject receding into the page or moving away. Creating the appearance of depth in a picture using colour temperature is certainly worth practising in your sketchbook.

Cold colours

33 SOMETHING COLD

Now sketch something cold!

DRAW A MANDALA

A finished mandala can look a little complex to the viewer, so here I will take you through a number of steps to create your own mandala in your sketchbook.

I love drawing mandalas – they have a definite structure yet allow plenty of room for creativity when you add numerous shapes and patterns.

What is a mandala?

A mandala is a circular design, symbolizing the notion that life is never-ending. Mandalas represent the universe and originate in Hindu and Buddhist cultures. They are beautiful motifs that allow artists to get creative and repeat patterns and shapes around the structure. Think of a mandala as a very elaborate spider's web that radiates from its centre.

Why draw mandalas?

Drawing mandalas can give you a handy formula for mindful creativity. Creating one every day is almost like journalling through drawing in your sketchbook. Mandalas can be small or large, simple or complex, themed or simply doodles.

SUSAN SAYS

As some mandalas take a while to create, I draw mine in stages, leaving them half-finished so I can carry on with them the next time I open the sketchbook.

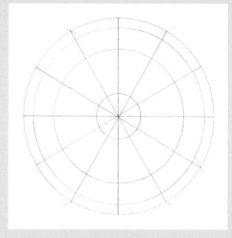

1. Draw your foundations

The starting point for your mandala is the circle. Use a pair of compasses to get a perfect outer circle in pencil – this will determine the final size. Draw several circles as additional guides inside this. I usually draw a small circle in the centre first, with a few more radiating out from this. The gaps between the circles don't have to be equal.

Once you have your circular guidelines, divide your mandala into sections. Here, I have used 12 sections, and used compasses to mark out the sections evenly.

TOOLS & MATERIALS

- Pair of compasses (or several circular objects of varied sizes to draw around)
- Sketchbook page or paper
- Pencil
- Eraser

- Fine-liner ink pen (I used an 0.3 UniPin fine-liner pen)
- Paint for adding colour (I used gouache)
- Fine paintbrush (I used a size 0 watercolour brush)

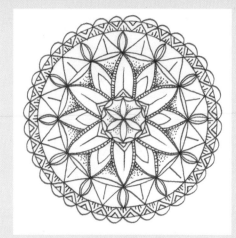

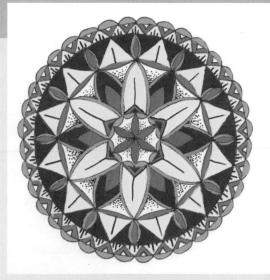

2. Pencil in the major shapes

Starting from the centre, work outwards, marking the major shapes in pencil. Draw a line, curve or other motif in one of your sections. Then repeat this in each of the remaining sections of the mandala. Continue to work outwards until you reach the edge of the mandala.

Remember that whatever you draw in one section of the circle needs to be drawn the same way in all sections. I find it easier to turn around the paper or sketchbook as I work. Also, don't be afraid of blank spaces: a good design will have balance in detail and space, light and dark.

3. Pen lines and details

Go over these pencil lines in a black fine-liner pen. Erase the pencil guidelines and continue to work on the mandala adding smaller elements and more details – let this grow organically. Sometimes it's nice to repeat an element on the mandala – for example, petal shapes in the centre as well as around the edges. I have also used dots as a shading technique twice in this demonstration.

4. Add colour (optional)

Adding colour is a great way to finish your mandala. For this demonstration, I have used four shades of gouache paint: primary yellow, orange lake light, cobalt turquoise light and quinacridone magenta. I also enjoy using colouring pencils, watercolour, brush pens and acrylic paints on my mandalas.

Play with colour combinations: you may wish to use one colour in several tones, introduce complementary colours or use all the colours possible (refer to page 44–45)! That said, this stage is optional – mandalas work perfectly in black and white too.

SUSAN SAYS

If you are adding colour afterwards, use a waterproof ink pen at this stage so that it doesn't smudge when you apply the paint at the last stage.

SUSAN SAYS

As I've mentioned before, I recommend taking your own source photographs to work from. If you see something interesting and don't have time to sketch it there and then, you can snap it instantly and once you are back home, you can sketch from this photograph.

You may also like to sketch in a medium that doesn't travel well (such as a dip pen and a bottle of ink) and so a reference photograph can be handy in that instance too.

Using your own photographs as source material also removes any potential problems with copyright that you may encounter if you work from a photograph taken by someone else (see page 51 on originality and copyright).

35 SHOPPING

Time to go shopping! I enjoy breaking out a sketchbook in the course of my weekly shopping or taking a special trip out to one of my favourite independent shops for a spot of drawing. You may choose to sketch a row of shops, the inside of a shop, your food shopping bags or the last thing you bought.

On this page, I sketched two of my local shops using a dip pen and black Indian ink. I worked from photographs that I'd taken of the shops when out on a walk.

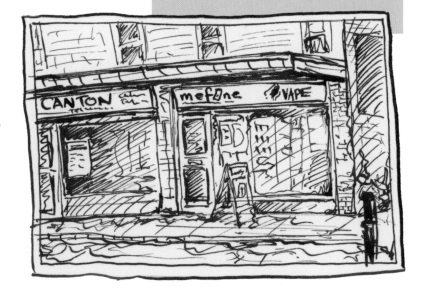

36
PAINT AND PAINTBRUSHES

As an artist (and art material addict) I am slightly obsessed with paint and paintbrushes. I love collecting or buying new ones and trying them out. I also love sketching and drawing them. Why not try it yourself?

In the image here I sketched the paintbrushes loosely in a hard pencil. I went over this with a calligraphy dip pen dipped in black Indian ink. I then added a little watercolour to add some colour, highlights and shadows.

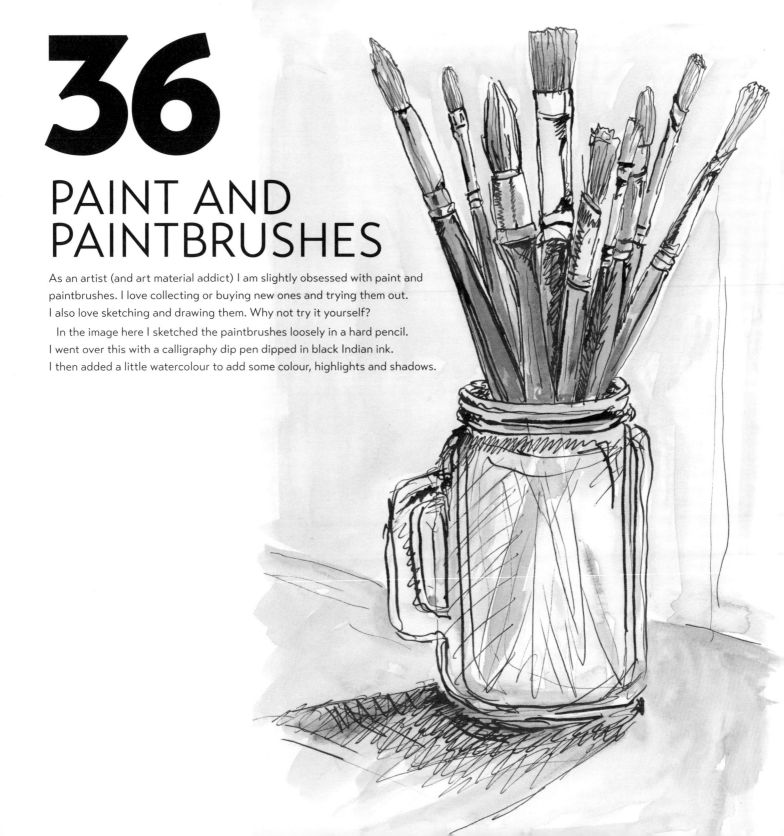

37 NUMBERS

Let's try numbers as a starting point for sketching. I include a number prompt every year as a sketching prompt in my annual 30-Day Sketchbook Challenge as it works so well. Here are some helpful suggestions for ways that you could interpret this prompt:

- Draw a whole page of numbers (as shown above);
- Look for signs, plaques or house numbers and sketch those;
- Find an item in your home that has numbers on it (such as a computer keyboard or oven display) and sketch that;
- Roll a dice and sketch an object that many times over – so, if you roll a two, sketch an object twice;
- Pick a number at random and see what comes into your mind to sketch. For the number 7, you could look for something with seven sides or draw a seven-pointed star, as shown above.

38 PETS

As a nation of animal lovers, drawing your pets (or those of others) can be a great pastime. From cats and dogs to small furry creatures such as hamsters, rabbits and guinea pigs, to fish in a tank or birds in a cage, there is such a variety in the pets we keep. I have many friends who are pet lovers and who adore sketching their furry or feathered friends. See what catches your fancy and get sketching.

In the sketches here, I doodled some cartoon-like cats and dogs in black brush pen.

39 CACTI AND SUCCULENTS

I find cacti and succulents such fascinating plants and these can also be fun to sketch and draw in a sketchbook. Sometimes I will use an ink pen to complete some doodles; other times I like to add a little paint to bring some colour.

To create these images, I sketched some basic cactus shapes in pencil, using a reference book as my guide. My cacti aren't exactly true to life but the basic shapes are inspired by real species. From there, I mixed some acrylic paint colours and played with bold paint applications over the top.

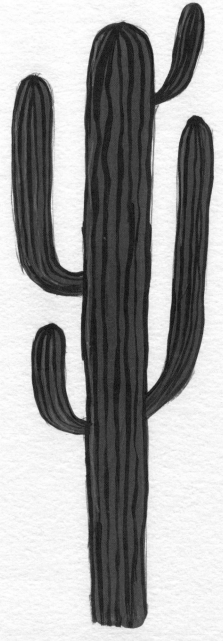

40
CLOTHES

Now, I am sure we all have some clothes hanging about our cupboards and wardrobes that we could draw! Clothes can be a fascinating window into our personality. In addition, fashion illustration is a whole category of drawing in itself.

Whether you choose to sketch a few of the items from your own wardrobe, pick out some interesting patterns from the fabric itself or go for full-on fashion illustration, the choice, as always, is yours.

41
HANDS

Hands are fabulous subject matter for artists. They are always there, so something you can return to time and time again when you want something to draw but don't want to look far for your reference!

A detailed pencil sketch of a hand can take a while, but you could also sketch a hand quickly or try to capture movement as a hand moves.

In my own sketch here I decided to take a more stylized approach to drawing hands. These drawings are experiments in what is known as a Hamsa hand, which is a symbolic open-hand image that is said to be a sign of protection.

93

42
GEOMETRY

Geometry is one of the oldest branches of mathematics and is all about studying or drawing various shapes and their relation to each other. It was always something that fascinated me as a child, as it combined mathematics with drawing and art.

On this page, I decided to experiment with a pair of compasses and drew circles to create foundations for constructing stars, hexagons and triangles.

You can of course play with geometry in your own way, but these are a few examples of basic geometry to try for yourself.

SACRED GEOMETRY

Sacred geometry is fascinating to study as it assigns meaning to geometric shapes and proportions. I have seen it described as 'the architecture of the universe'. Artists, architects and designers frequently use sacred geometry as the basis for creating art. Many religious buildings, temples, sculptures, and paintings are based on these foundations, and you can see geometry in nature, too, in the form of the spiral of a snail's shell or the petal formation of a flower.

TOOLS & MATERIALS
· Pair of compasses
· Pencil

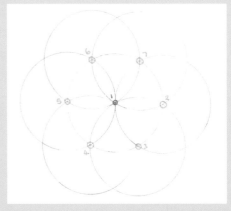

1. Begin by drawing a circle of a 2cm (¾in) radius using a pair of compasses. The centre of the circle is point 1 in red. I placed the point of the compasses on point 2 (yellow) to draw another circle on its edge.

2. Where the second circle intersects the first it creates two more points. Draw two more circles here and keep drawing circles at the intersections until you have six circles in total around the first. The centres of these circles are marked in yellow from 2 to 7 to help you see where the point of the compass goes.

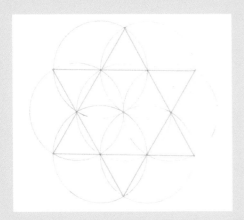

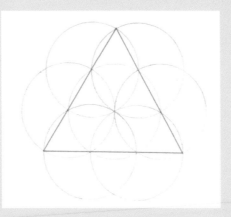

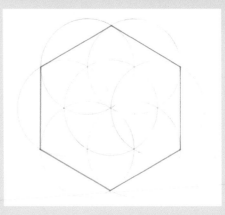

3. Once this seven-circle structure is established, you can find shapes within it – for example, this six-pointed star drawn in blue pen.

4. Within the same basic structure, I have found an equilateral triangle (a triangle where the sides are all the same length).

5. In this same structure, I have now found a hexagon.

6. The structure can then be expanded further by placing another layer of circles at the intersection points on the outer six circles. This adds another 12 circles to the grid.

7. Within this new structure I have now found a grid of hexagons.

43 WHAT'S IN YOUR POCKET?

safety pins

It's always an interesting exercise to turn out your pockets and draw what you find! For me, these are either small, random items that my little girl has handed to me (such as pebbles or hair bands), or everyday items that I need to use, such as my keys, some money, tissues or my phone.

Turn out your pockets and see what you find. Do this whenever you want to sketch something small. If you don't have pockets in your clothes, try searching in the pockets of a bag instead!

coins

pins!

hairclip

hair band

lip balm...

fluff!

pencil

stones and pebbles

a receipt

phone cable

a tissue

Post office Ltd.
www.post office.ro.u

02/09/2021 16:08

96

44 FURNITURE

Furniture can be functional and plain or extravagant and detailed – it's an interesting and never-ending subject to draw.

You can sketch the furniture in your own home or look elsewhere: furniture shops, antique markets or designer boutiques. Some items of furniture can have great significance in the home – Grandad's chair or the family dining table. See what catches your fancy and sketch it.

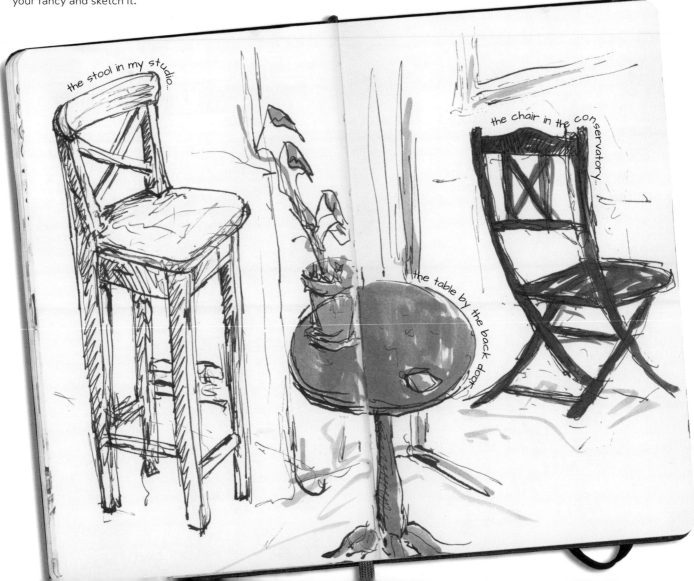

the stool in my studio...

the table by the back door

the chair in the conservatory...

FLOAT OR SINK

Today the prompt is to draw something that floats or sinks. We are selecting a subject based purely upon this characteristic – whether it is buoyant on water, or sinks to the bottom.

Consider also whether you will draw the item in the water as if it were at eye level, from underneath the water as if you were looking up at it or looking down at it from above. Whether an item is on the surface or beneath the water will change its overall effect in a sketch. A stone at the bottom of the water viewed from above will feature a layer of water to draw, which may distort the shape of the stone itself.
A curious challenge for the sketcher!

There is a lot to consider here, but always remember the part that water plays when constructing a composition for a sketch.

46 CABLES AND WIRES

If you are anything like me, you may well have lots of wires and cables around the house. Feel free to sketch a single wire or cable wherever you happen to find it or spend some time arranging several on a table and sketch from that.

In the sketch here, I laid out a black and a white cable on my desk and sketched the shapes created where the cables overlapped. I used a soft pencil (3B) for the black cable and a hard pencil (3H) for the white cable.

47 MACHINES

Machines provide a wide range of options from which you can choose something to draw, today. Machines are all around us and can be small or large and very different in terms of their design and complexity.

Think about all the machines that you use in your daily life, from the kettle, toaster or coffee machine when making breakfast to larger appliances such as the washing machine, dishwasher or oven. Maybe sketch something that is easily found in the home, something that fascinates you, or that has some interesting workings inside it.

48 TREES, WOODS AND FORESTS

You can choose to draw a single tree, a local woodland, or an entire forest for this prompt. Maybe spend a day on each if this subject really appeals to you. I always recommend sticking with a prompt and repeating it if it sparks your creativity.

Trees themselves are a fascinating prompt – you will always be able to find a live specimen to draw within a short walk, which is why they are perfect as a prompt for daily sketching.

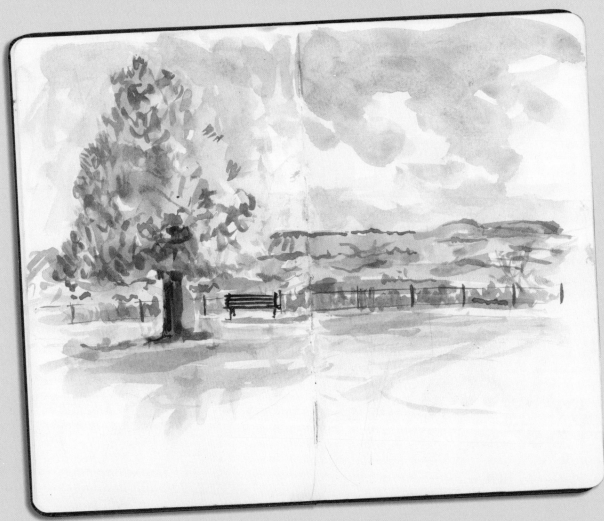

WOODLAND WALK SKETCHING EXERCISE

Take a 10-minute walk every day for a week in your local area. Spend those 10 minutes observing and looking at the trees around you. Remember to slow down and look properly, rather than trying to cover as much ground as possible in the time allowed.

Pay attention to all your senses as you walk, from smell to touch. Then, when you are ready, choose a tree that catches your attention and sketch it for just five minutes.

The idea is that you immerse yourself in the environment and sketch a different tree each day as a record of each walk. After a week (or even a month if you really get into the habit), you will end up with a comprehensive record of the trees on your walking route.

49
FAMOUS PAINTINGS

Looking to famous paintings as inspiration is a recognized learning technique in traditional art and one I regularly teach to my own sketching students. Examining composition, colours and techniques of great artists can really inform your work and give you a better understanding of how different artists interpret their subject matter and the specific brushstrokes, colours or shapes that they have used.

So, for this prompt, find a famous artwork and recreate all, or a portion of it in your sketchbook. This might involve visiting a gallery, looking in a book or researching online. (However, please do see my note on page 51 about originality and copyright before starting on this prompt.)

The sketches on this page were made when I was visiting a museum and art gallery as an art student. Sitting in the gallery and sketching the art in front of me was a great way to absorb the art and understand exactly what the artists were attempting to do.

I find this prompt helpful when out at galleries for having a record of what I've seen as taking photographs in galleries and museums is often not permitted.

After Miró, 'Woman in Front of the Sun'.

After Picasso,
'Las Meninas'.

103

For this prompt we look at famous landmarks. These are features in our landscape that stand out, are easily recognized and can be seen at a distance. They could be natural, or man-made structures, such as the Statue of Liberty in the US, the Eiffel Tower in France, the Great Wall of China and Tower Bridge in the UK.

This sketching prompt may give you an excuse to sketch an iconic structure or you can look for landmarks in your local area. For example, I live in Woking, UK, which is famously the setting of the H.G. Wells book, *The War of the Worlds*. There is a statue of one of the alien tripods in the town centre, so I decided to sketch this as my 'famous landmark'.

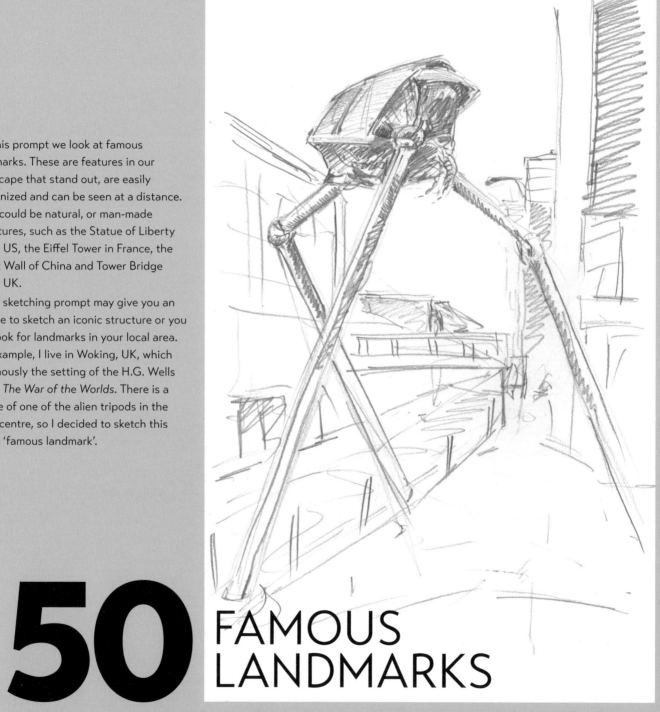

50 FAMOUS LANDMARKS

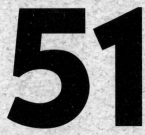

51 WORK

What does work mean to you?

This prompt is slightly looser than previous ones, but it does give you lots of scope for a sketch. I spend most of my time in my home studio: writing this book, sketching, drawing, painting and printmaking, so I chose to sketch the place in which I work.

Here I have made a pencil sketch of one end of my studio. This was a great opportunity for me to look at the application of one-point perspective (explained below), and construct the end of the room from there. If you look closely at the picture, you can see the vanishing point marked out.

This is the point at which all the lines of the ceiling and floor join to meet, and is the point at which your eyes are looking at the view – hence the term 'one-point perspective'. From there, I started to add in more details until the room began to take shape.

52 FACES

The human face provides us with endless possibilities for our sketches. You could look at sketching realistic faces, stylized faces, cartoons or doodles; and the good news is that there will always be a face available to draw – just look in the mirror!

I love to do blind contour drawings of faces (see pages 40–41 for an exercise on blind contour drawing). To recap, in this technique you look only at the subject – the face – and not at your paper as you create a simple line drawing. It is a fun exercise that can take the pressure off creating a realistic portrait, especially if the idea of drawing faces fills you with dread.

There is an interesting quality to faces drawn using this technique: it captures the general essence of the face, as many of the important features have been recorded. Why not try it with a friend or family member sitting for you (or by looking in a mirror)?

In the sketches here, I doodled some face shapes using different pens, allowing the drawings to overlap each other.

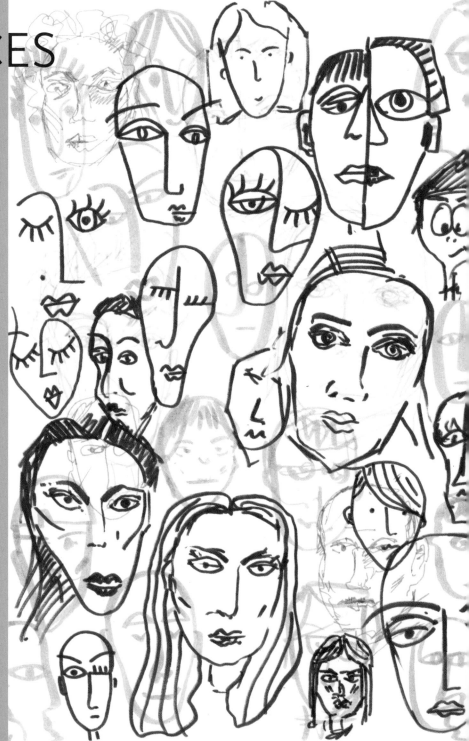

53 BOTANICAL STUDY

Take your time to select a plant and look closely at it. Lay it out on the table in front of you and begin your study.

Try to depict the item as accurately as possible while still allowing for a sense of fluidity and expression. Working in either colour or black and white is fine. You may find that this subject takes you longer to complete than other sketches and prompts in this book, and working on it over several sessions can help if you are limited for time on a given day. There is no rule that says you must finish a sketchbook page in a single sitting. It is often helpful to return to a study another day, with fresh eyes.

BOTANICAL STUDIES

A botanical study or botanical art is the more accurate and realistic rendering of plants to capture the details of the flower or plant being studied. In some ways it is both a record of the species being studied and a work of art in its own right.

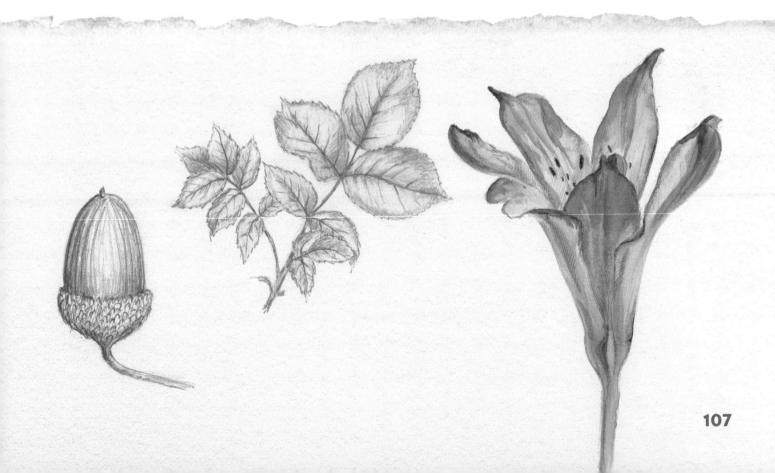

54 SOMETHING THAT SMELLS GOOD

Our sense of smell is a strong, evocative one, and can transport you instantly to a time, place or emotion. Pleasant smells can bring a smile to the face as you are instantly reminded of something positive. Therefore, this sketching prompt is all about drawing something that smells good. You might like to sketch a cup of coffee or your favourite perfume. Or perhaps you might draw a scene that you are transported back to: your dad mowing the lawn when you were a child, or the memory of someone cooking a roast dinner.

Go with your gut and draw the first thing that comes to mind, or maybe a few little thumbnail sketches of things that you associate with pleasant smells.

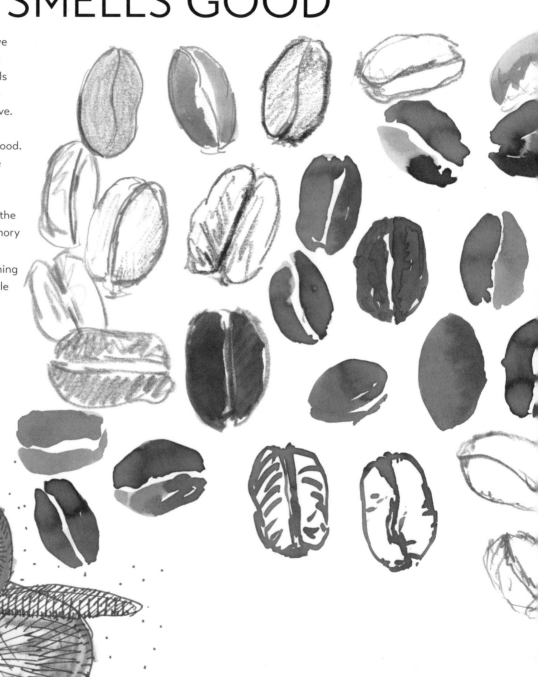

I do love a contrasting prompt and this one is all about drawing something that smells bad. As I mentioned in the last prompt, smell is a very powerful sense and bringing attention to a smell you dislike can also evoke a strong reaction. Take a moment to think about a smell that you instantly dislike. It could be a food that you can't stand or a foul smell associated with an unpleasant experience. You have full permission to draw the disgusting and dirty today!

For this prompt, I sketched a sunflower that had withered away. The smell of the water in a vase in which the flowers have dried out and rotted is one I don't like, and is such a contrast to the beautiful colours and smells of flowers when they are freshly picked.

SOMETHING THAT SMELLS BAD

55

wooden

Pearl

56
JEWELLERY

Jewellery can be incredibly small and intricately detailed and therefore a very tricky prompt to attempt. It is fascinating to look closely at something so small and valuable, and to try to depict some of its beautiful qualities on the sketchbook page.

It may be that you choose to sketch a family heirloom, a piece of jewellery that is special to you or even design your own jewellery. Here, I have sketched a few of the pairs of earrings that I possess. These sketches didn't take long – five or 10 minutes at most.

resin and wood?

big hoops

57
TECHNOLOGY

Wow, when I think of how much impact technology makes upon our lives nowadays, it is staggering. From my phone to my computer to the navigation system in my car, technology helps me so much in my personal life and work. It is worth spending a moment to appreciate all the technology in our lives.

I decided to sketch my phone for this prompt as the single most useful piece of technology in my life. I don't pay much attention to it, but I would be lost without it.

What does technology mean to you? What tech can you draw today?

58 SPORT

I love watching sport, but until I wrote this book, I had never sketched sports or sport-related subjects. This is one of the benefits of a sketchbook challenge – sketching something you have never studied before. Maybe you have a favourite sport you like to play or watch?

You could depict a sportsperson, visit your local sports club and sketch what you see, sketch a match on TV or an item associated with sports, such as a net, ball or racquet.

This is quite a broad topic and gives lots of scope for sketching: it could keep you going for weeks if you enjoy what you have started.

For the image below, I made a pencil sketch of a tennis court and then added some loose acrylic paint over the top to give the impression of two people playing tennis. This took around 15 minutes to complete.

59 FEATHERS

Feathers have great textures and varied shapes to play with, so study the details carefully, and get drawing.

On the page below, I have created a series of pencil explorations of feather shapes.

60 A FEW OF MY FAVOURITE THINGS

The idea here is to gather a few items that you consider to be your favourite things. Whether you find one or two items, or set up a whole display to draw, it's up to you. It's interesting to see what happens when we draw items that we are emotionally attached to and make us happy, which is what we are doing here. Your interpretation of your favourite book or a photograph of your family may be very different from that of an everyday object such as an apple (unless you have a huge love of apples, that is!).

I chose to sketch four little succulent plants that I have here in my home. I love collecting weird and wonderful cacti and succulents, and they definitely make me smile.

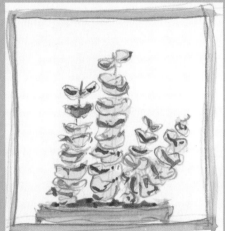
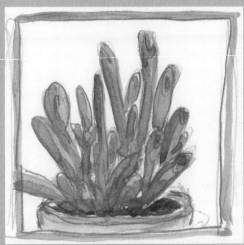
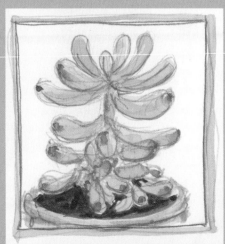

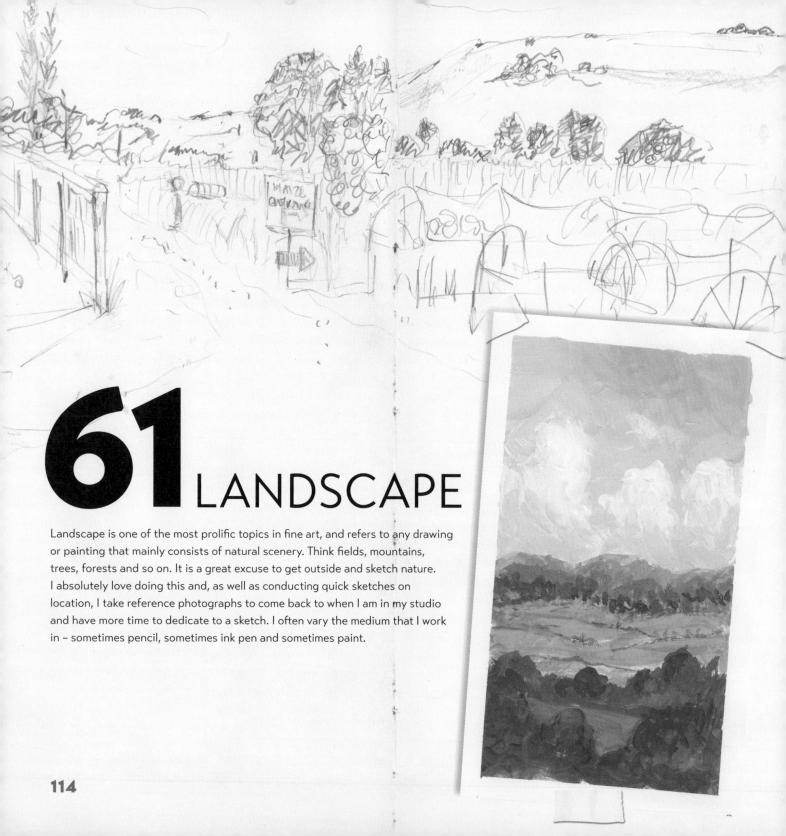

61 LANDSCAPE

Landscape is one of the most prolific topics in fine art, and refers to any drawing or painting that mainly consists of natural scenery. Think fields, mountains, trees, forests and so on. It is a great excuse to get outside and sketch nature. I absolutely love doing this and, as well as conducting quick sketches on location, I take reference photographs to come back to when I am in my studio and have more time to dedicate to a sketch. I often vary the medium that I work in – sometimes pencil, sometimes ink pen and sometimes paint.

62 SCI-FI AND OUTER SPACE

Welcome to the weird and wonderful world of science fiction and outer space. You might be inspired by your favourite sci-fi movie, by space itself – the planets and stars – or by whatever captures your imagination.

I decided to paint a space scene using watercolour paints. It was a chance to get out the indigo watercolour and blend some other colours into it to create a fantastical spacescape. I also wanted to include a planet or moon at the bottom to give context, and to add some small white dots for stars.

63 COINS AND MONEY

Have you ever looked closely at a coin or bank note? They are fascinating and detailed, and take an incredible amount of skill to design and produce. I don't want you to start counterfeiting legal tender but take a little time today to sketch some currency. You could read the prompt as an opportunity to get inspired by the topic of money and create a sketch based upon this. For me, this was a chance to play with some new metallic ink!

64 KINGS AND QUEENS

Paintings of royalty and other important figures in history have been a feature of the art world for years. You may choose to sketch our current monarch, study an Old Master painting that captures your attention, or take this prompt in any direction that you want. I did the latter and drew the king and queen from a pack of playing cards.

65 TV AND FILM

As a huge lover of the screen, I find films and TV an endless source of inspiration. Making a sketch of the artwork or scenes from your favourite movies, or of the characters of your favourite programmes, can be a relaxing way to spend an evening.

I love 'fan-art', wherein people – i.e. fans! – take inspiration from a film, franchise or TV series, and lovingly sketch its imagery. Think of your favourite film or TV series, and search online to see whether any fans have been inspired to create art from it.

66 SOMETHING MADE OF WOOD

Choose something wooden as your starting point today. This can be a wooden clothespeg, spoon or chopping board, all the way up to larger items such as tables, sheds and entire buildings.

Wood has a wonderful colour, texture and grain to it, and it is a good idea to study the texture and the natural patterns in detail, as well as examining the form of the object you select.

For the sketches shown here, I looked at a wooden clothespeg and made studies in pencil and in ink. I used two shades of watercolour ink as a loose background layer, to roughly depict the colour, then added in some pen drawing using black Indian ink and a calligraphy dip pen. This gave some unexpected qualities to the black lines where the ink pen was full at times and caused splodges, and at other times was empty, which allowed for lighter scratch marks.

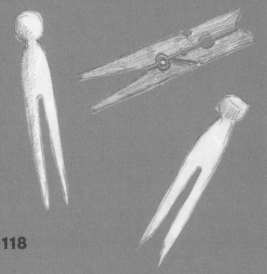

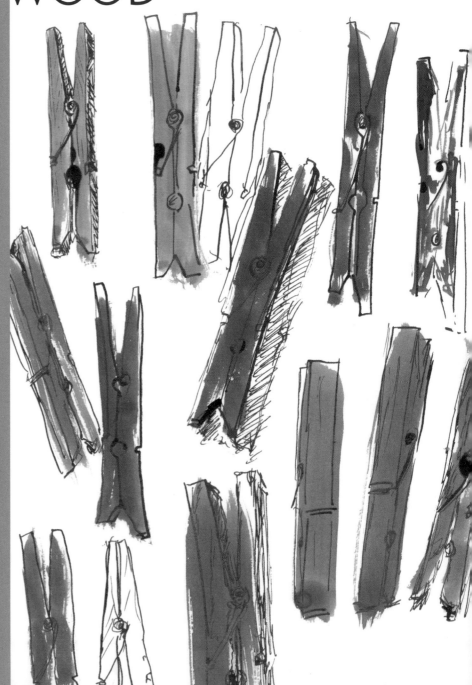

67 SOMETHING MADE OF GLASS

In contrast to the earthy, natural, opaque element of wood on the previous page, we now look at glass. Glass is transparent, smooth and often reflective, and the play of light on an item, as well as the overall shape, can be quite a challenge, even for the experienced sketcher. My best advice would be to go slowly and steadily and really look hard at what you see. Draw what is in front of you and notice the little pockets and shapes of light. It can be useful to draw the previous prompt (wood) and this one in quick succession to appreciate the differing qualities of the materials you are sketching.

SUSAN SAYS
Once you have sketched something made of wood and glass, why not look at objects made of other materials, such as metal or plastic? Every material has a unique texture and quality. You could make notes by each sketch to remind yourself which material was easy to depict, which was a challenge, and what you liked or disliked about each. Annotating your sketches in this manner can be helpful, especially if you are revisiting the sketches months later.

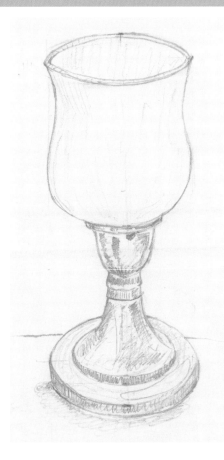

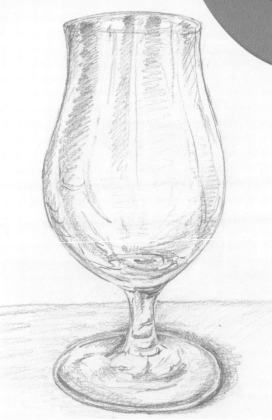

68 STREET SCENE

Sketching a street scene can be a fulfilling way to fill your sketchbook – especially if you do it from the comfort of a café table! I love grabbing a seat outside, ordering a strong coffee and sketching the street that I see, using a portable, hardback sketchbook and basic tools such as a pencil or fine-liner pen.

If you're out and about, perhaps start by making a few quick sketches on location to get a feel for the scene, and take a photograph to refer to when you have more time to work on a sketch. You can then add more detail or a little paint.

Sketching street scenes is an useful activity to do in your local area, or to record places you visit. Observe the perspective and identify the horizon line, so that the tops of all the buildings follow the same line across your view. Look, too, at the foundations, before adding in the small details at the tops of the buildings.

5-5-5 SKETCHING EXERCISE

Give yourself an hour to complete this exercise: go on a journey and record what you see. It makes a great task for a lunch hour or a break from work.

TOOLS & MATERIALS

· Portable sketchbook
· Drawing implement (pencil, pen, coloured pencil or brush pen)
· Alternatively, grab your portable sketching pack (see page 32)

INSTRUCTIONS

1. Find a starting point for your journey. Walk for five minutes.
2. Stop wherever you happen to be and sketch the view for five minutes.
3. After those five minutes are up, shut your sketchbook and go for another five-minute walk.
4. Stop again, and sketch your next view for five minutes.
5. Do this five times in total.

Enjoy your street-scene sketching journey.

TAKE FIVE...

At each stop, try to capture the essence of the view with quick gestures and energy. Accuracy is less important when you have only five minutes. Sometimes, the view will be beautiful; at other times it may be one you wouldn't usually sketch - It could be rural or urban; the important thing is to try not to overthink each sketch. Just draw whatever happens to be in front of you.

After five mins...

10 mins...

15 mins...

20 mins...

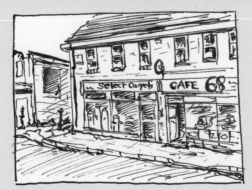

25 mins.

SUSAN SAYS

If you are unable to go out to sketch, or if you live far from a town with streets, why not look online at Google Maps and make use of the street maps feature? You can travel anywhere in the world and transport yourself to street level to see what a person walking that road would see. This site is primarily designed to help people to navigate (it is a map, after all...), but it is also a great way to travel, virtually, across the world and sketch a place you may not have the opportunity to visit in person.

69
RUBBISH

Today, our goal is to observe and sketch the things we throw away.

Here are a few suggestions for tackling today's theme:

- Rifle (safely!) through your waste bin to see what you can find and sketch it;
- Draw the rubbish bin itself;
- Sketch a crumpled-up item, such as a sheet of paper or a crushed drink can that is ready to be recycled;
- Sketch the refuse collectors and the lorry that collects your rubbish each week;
- Select a piece of rotting fruit, such as an apple core, and sketch that.

To create the image on the right, I first made a collage of items that I had rescued from my rubbish bin (see page 78 for more on collage). This included a shopping list, a receipt, a dried leaf, some scrap fabric, a teabag wrapper and a garden centre catalogue. I stuck these onto a sketchbook page using PVA glue. I then painted a layer of PVA glue mixed with a little brown ink to create a mid-toned layer over the collage of rubbish and left it to dry.

Using a pencil, I sketched the kitchen bin from where the rubbish came, on top of the ink and PVA glue layer. Lastly, I added some acrylic paint over the top to paint the bin and complete the sketch.

70 SWEETS AND TREATS

Time to find some sweets, chocolate, cakes or other treats and use these as inspiration for sketching. You could choose a single item and study it in detail, using your favourite sketching materials, or sketch the outlines or general shapes of a selection of sweet treats.

For this prompt, I created some sweet shapes across the sketchbook page with a 0.5 fine-liner pen. Also pictured are some doughnuts created using acrylic paint. I mixed up a brown to create the actual doughnut, then added a layer of icing over the top, finishing with the sprinkles.

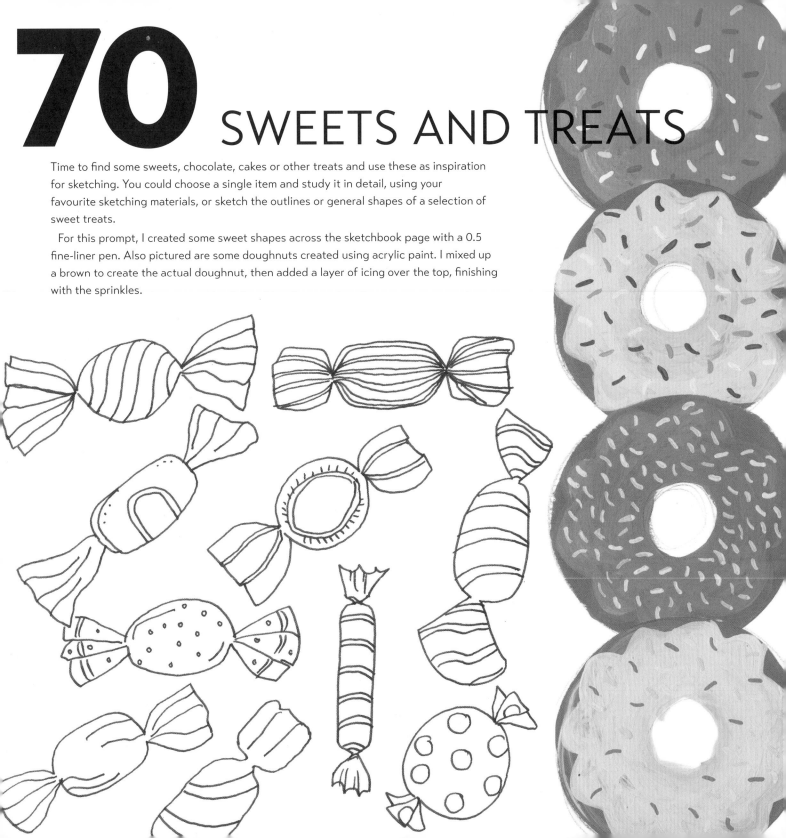

71
INSPIRED BY MUSIC

Do you play an instrument or have one at home? Is there a particular album cover with artwork that sticks in your mind, or are you inspired by the music itself? Today, music is your muse!

124

72 CAFÉ OR RESTAURANT

Drawing when out and about is a great way to integrate sketching into your day-to-day life, and is a huge part of building a regular drawing habit: honing the instinct to take a sketchbook wherever you go. Being confident enough to sketch in public is also a big hurdle for many of us – it is too easy to keep our sketching habits hidden away at home, and to feel shy about revealing our often uncertain efforts at capturing a new subject.

However, I believe that we should nurture our need to sketch so that we become confident enough to break out a sketchbook at any given opportunity!

When you are sitting in a café or restaurant there is so much you can draw, from the cups and plates to the coffee machines and the customers. Sketch a tiny detail to get you started, or sketch the full view before you.

I love sketching with the seasons. What I mean by this is that, when it's summer, I love to go outside and sketch the outdoors; equally, when it's winter in the UK, I love to sketch Christmas-themed designs and images. But there are so many other celebrations across the year that I couldn't write this book without mentioning them as inspiration – whether it's Easter, Chinese New Year, Valentine's Day, Eid al-Fitr, Diwali, Hanukkah, Remembrance Day, Anzac Day or Bonfire Night.

74 STONES, ROCKS AND PEBBLES

Time to go on a stone hunt. Look for unusual shapes, tiny pieces of gravel, interesting colours, smooth flat surfaces, jagged edges, huge rocks or anything else that catches your eye.

 The sketches shown here are a composite of two different pages from my sketchbooks. The first is a series of pencil sketches done of the same stone. For the second, I examined some stones I had collected from the garden, as well as a few reference photographs, to create some studies in watercolour.

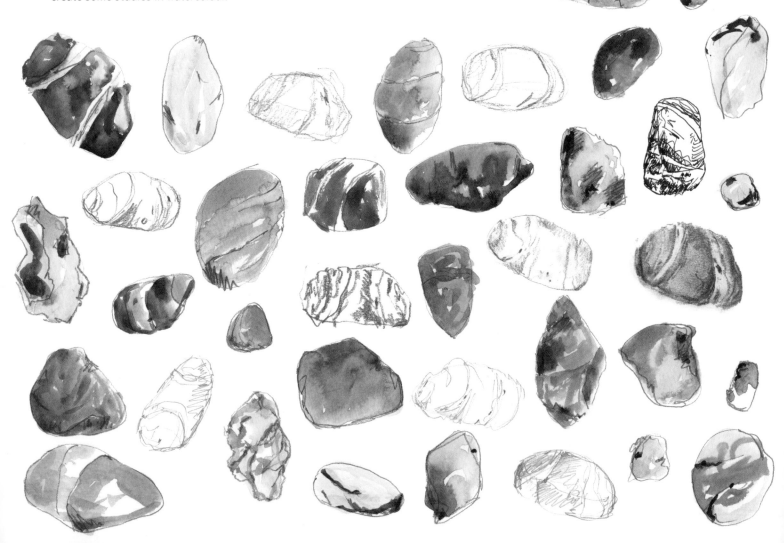

75 SYMBOLS AND SIGNS

We encounter, and use, hundreds of symbols and signs in our everyday lives, from the road signs that tell us how fast to drive, to the symbols on our food packaging, right down to the characters on our phones or computers: **@£$%^&*#.**

Spend the day paying attention to the signs and symbols around you and sketch them as you go along – you may find you're sketching quite a lot!

The sketches shown here are my own interpretations of some iconic symbols recognized worldwide. I sketched the outlines in pencil and then added colour with watercolour paint.

Clockwise, from top right, Peace, Yin and Yang, Male and Female, and Om (centre).

76
ABSTRACT

Abstract art is any form of art that is non-representational, and artists throughout history have approached abstract work in different ways. One definition of the word is, *'relating to or denoting art that does not attempt to represent external reality, but rather seeks to achieve its effect using shapes, colours and texture.'*

So, today, I would like you to go abstract in your sketchbook, to make sketches and marks that don't aim to represent anything you see in front of you.

(*The Oxford English Dictionary)

SUSAN SAYS

This seemingly easy task can prove harder if you don't have a starting point:

1. Base your abstract sketch on your mark-making practices (see pages 38-39).
2. Research some artists who are well known for abstract work; study their processes or finished works and use these as inspiration for your own sketches. A few of these artists are listed below:

Jackson Pollock (1912-1956)
Wassily Kandinsky (1866-1944)
Mark Rothko (1903-1970)
Piet Mondrian (1872-1944)
Joan Miró (1893-1983)
Agnes Martin (1912-2004)
Kazimir Malevich (1879-1935)
Bridget Riley (b. 1931)

3. Try the 'Mindful circles' exercise again (see page 35), but this time, expand into working with other shapes. Let the pencil or pen walk across the page and see what happens.
4. Create a viewfinder. This is a piece of paper or card from which you cut a central 'window' to look through, to help with composition. Place a viewfinder over another sketch you have done, to isolate a small area. This area will look abstract as it will be just a small section of marks and shapes - you cannot see the whole picture. Use this section as a basis from which to create a new sketch.

77 WILDLIFE

I love sketching the natural world and there is so much wildlife around us to sketch.

Again, this prompt is very open to interpretation: you could sketch a single animal, insect or plant, or a whole scene depicting the wildlife in your local area.

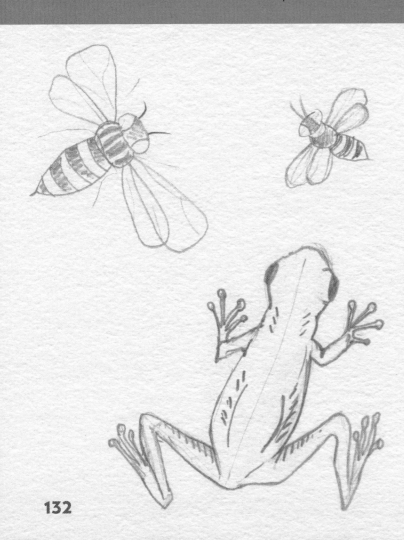

78 CLOUDS

Look up at the sky today – can you see any clouds?

Clouds are depicted in many great works of art; they can truly set a mood and make a piece more atmospheric or realistic. Sometimes clouds dominate a piece, and at other times they provide a beautiful compliment to the main features. They can be tricky to depict but are certainly worth studying.

Clouds are essentially water droplets or ice crystals floating in the sky. We can't see the water droplets themselves, from where we observe the clouds, but what we do see are beautiful formations of water vapour: some high up, some lower down and closer to the earth. Some clouds are fluffy and full, others are wispy and whimsical. Clouds in the early morning are also very different from those in the midday sun, in a night sky or at sunset.

Experiment with different painting techniques to see how you can show clouds on the page. Look at the colours of the clouds you are viewing: they are very rarely pure white. Look also at the light source on the clouds – where are the highlights and where are the shadows? You can choose to sketch from your own reference photograph, or from real life.

SUSAN SAYS
Look at some pieces of art that feature clouds and see how other artists have represented them. It is helpful to understand how the Old Masters showed the colours and forms of clouds in order to try it for yourself.

79 THE MOON

Think back to when I suggested making a mind map or brainstorming ideas before you begin sketching (see page 15). It can really help you to think of several ideas, then choose the one that attracts you most.

I had many ideas for this prompt: the man in the moon, a garden bathed in sunlight, phases of the moon and the line, 'the cow jumped over the moon' from the children's nursery rhyme, *Hey, Diddle Diddle*. All these kinds of thoughts are helpful, and this is what I want to encourage you to develop as you work through this book. You can store ideas to come back to later when you are stuck for sketch ideas, or for when you have more time to play.

I decided in the end to paint moon phases, as I have always had that in mind to do. Whether you choose to draw only the moon, or progress to the sun, or depict both, is up to you.

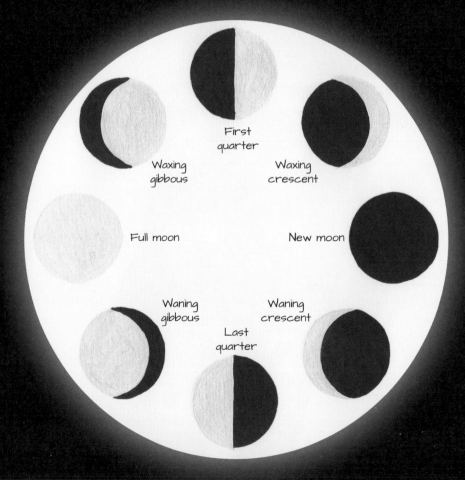

First quarter

Waxing gibbous

Waxing crescent

Full moon

New moon

Waning gibbous

Waning crescent

Last quarter

80 UNDER THE SINK

Yes, today is the day to open that often-forgotten cupboard under the kitchen sink and see what you find to sketch. This is an excuse to investigate spaces and places – such as everyday cupboards – that we wouldn't normally select to draw.

Why not look at the bathroom cabinet, the kitchen cupboard, or that drawer in your house that everything just gets scooped up into? You know the one!

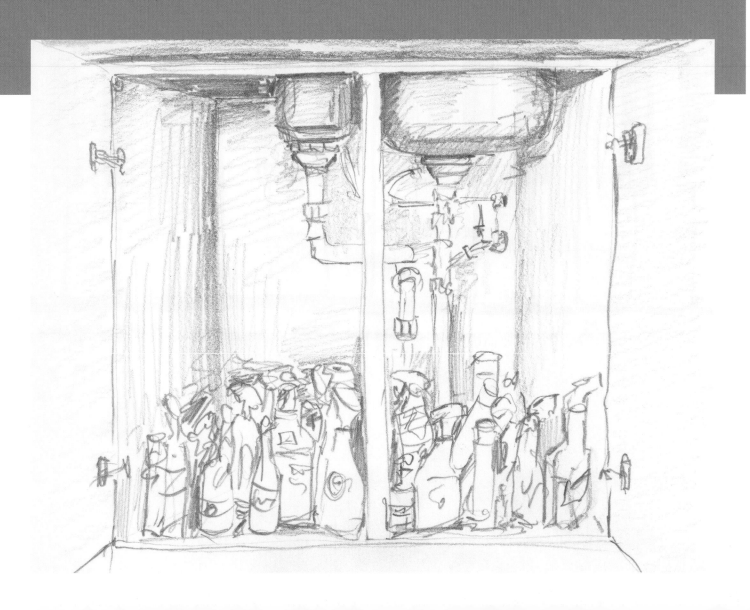

INSPIRATIONAL
WORDS
The text below the sketch
reads, 'Autumn is my favourite
season of the year. I love the
pumpkins, the harvest, the
autumnal leaves, the yellows,
oranges, browns, the depth of
colours. The weather isn't too
hot. The walks out in nature
+ lovely days.'

81

THE FOUR SEASONS

What do you associate with spring, summer, autumn and winter?

For this prompt, you may choose to draw something that changes with the seasons – a tree, perhaps. Or, you can select one season as a starting point, and sketch from that instead.

I chose to focus on autumn for the sketch shown here, as it is my favourite season of the year. I selected something that, to me, represented the season – pumpkins! I worked from some real-life pumpkins that I'd grown in my garden; I made loose sketches using layers of ink painted on with a paintbrush and dip pen. I also added onto the page some of my own thoughts about autumn, again using the dip pen and ink to accompany the images, which were thoughts that had occurred to me as I was sketching the pumpkins.

82 STILL LIFE

A still life is any drawing, sketch or painting that depicts inanimate objects, i.e. things that don't move. It is another prolific subject in historical and traditional art, and in older paintings you will often see fruits, vases of flowers, jugs, cups, bottles of wine and other household items. The artist may have arranged the items in a pleasing manner and then depicted them in their chosen medium. This art form gives artists the chance to explore colour, form and the contrast of light and dark – still-life arrangements are often lit with dramatic lighting.

Still-life studies are a fantastic way to build skills in representational drawing. However, a still life doesn't have to be completely realistic. All art is created with an understanding of artistic licence and freedom, so your own interpretation is hugely important. It is fun to play with colour and add your own style to a piece, so please be very free with this.

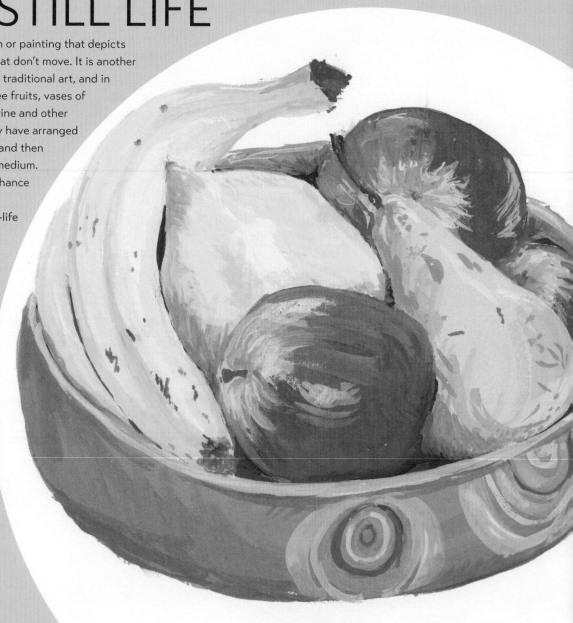

83 SOMETHING OLD...

These next two prompts work as a pair – something old and something new. You can sketch them independently or work on a contrasting pair of sketches.

As I was writing this section of the book, I looked over to my old sewing machine, which used to belong to my great-grandmother and has been passed down to my nan and then to me. I love this beautiful piece of machinery and it has a special place in my studio.

I decided to sketch my newer sewing machine too – both sketches are pencil drawings.

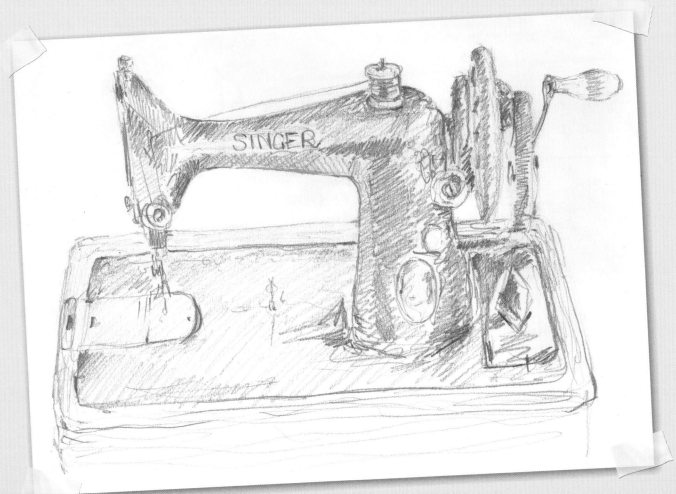

84...SOMETHING NEW

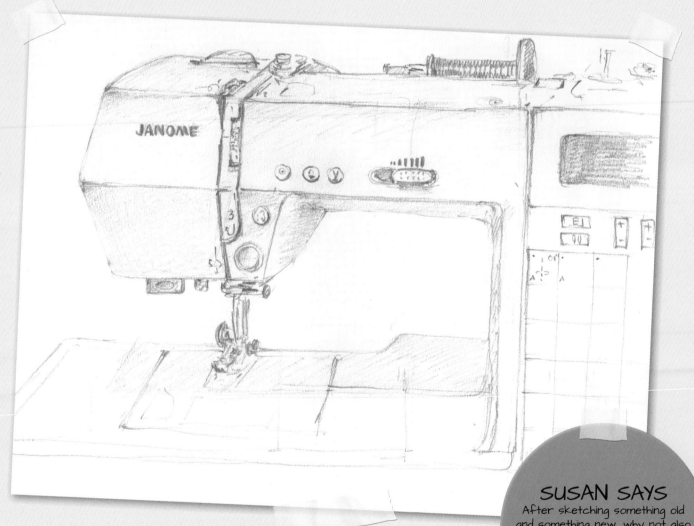

JANOME

SUSAN SAYS
After sketching something old and something new, why not also sketch something borrowed and something blue?

85 PEOPLE-WATCHING

Watching and sketching people is the perfect activity for a sketchbook addict. There are so many opportunities to study people in our daily activities. In fact, I think studying people as they go about their normal day is one of the most interesting things to do. It is also a useful skill to be able to capture the essence of a human face or figure when you have just a few moments to make some marks. You can observe your family in your own home, study your work colleagues from across the room or sit in a public area and watch people when you are out and about. My favourite places for doing this are public parks, on public transport and from a café window as I look out at the world and people walking by.

However, people do have this annoying habit of moving, so you may prefer to sketch people when they are sedentary, if this is your first foray. Why not try watching people in a café, who will usually be sitting in one position, people watching TV or reading, or on your train or bus? Sleeping commuters are much easier to draw than conscious ones!

Once you've gained confidence in capturing stationary people, you can move on to those who are walking, running or moving in other ways. I consider people-watching to be more about capturing the essence of the person that you are watching, and not about achieving perfection or worrying about the resulting sketch. I suggest grabbing a single tool such as a pencil or a pen and taking no longer than a minute to capture a figure with quick and fluid marks that give a general impression of that figure. Highlight the details that are the most interesting to you: this could be the way that someone is standing, the twist of their body, the tilt of their head, the expression on their face, or even something that they are holding. Have a go and see what happens – this type of sketching can fill pages of a sketchbook in a single session if you go with the flow and simply draw what you see.

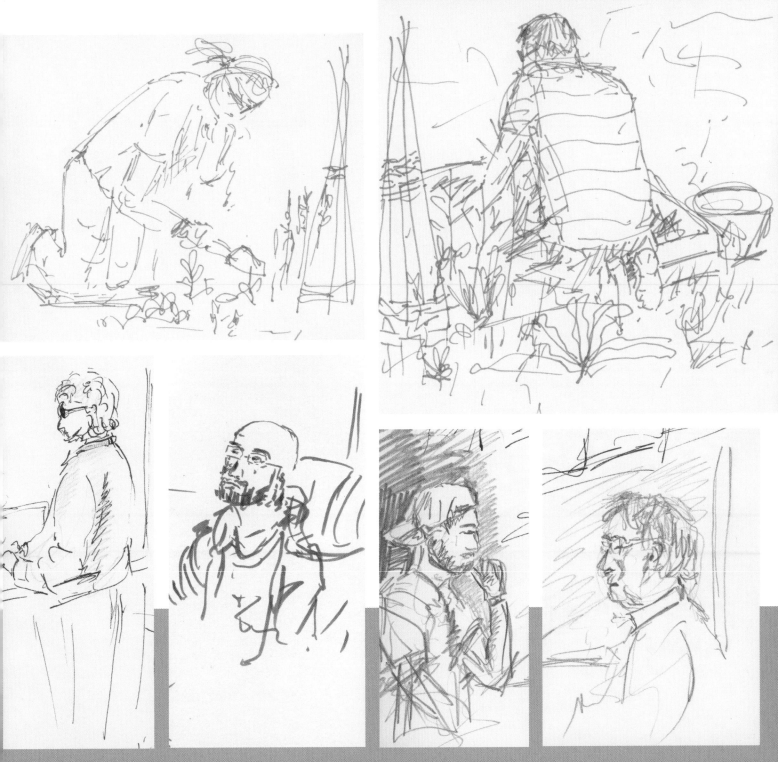

86
BOOKS

I love reading, and books play an important part in my life. I enjoy reading fiction but I am also inspired by my many art books.

There are so many ways in which books can inspire us to sketch, from drawing a stack of books, or the contents of our bookcases, to being inspired by illustrations and cover designs. We can also look to the stories and words as a starting point for sketching.

So, today, think about ways in which you can use books to inspire you to sketch.

87 SOMETHING YOU USED TODAY

For this prompt, the idea is to find something that you used today as your starting point for sketching. You could sketch the object itself or allow your mind to wander and sketch the scene around the object. By sketching on a theme like this, we are cataloguing and recording our everyday activities. The mundane becomes interesting, and we begin to really look at our immediate surroundings.

For this prompt, I drew a little cup that I use for my morning coffee. I sketched it in a few different positions to have a play with composition and see what I liked.

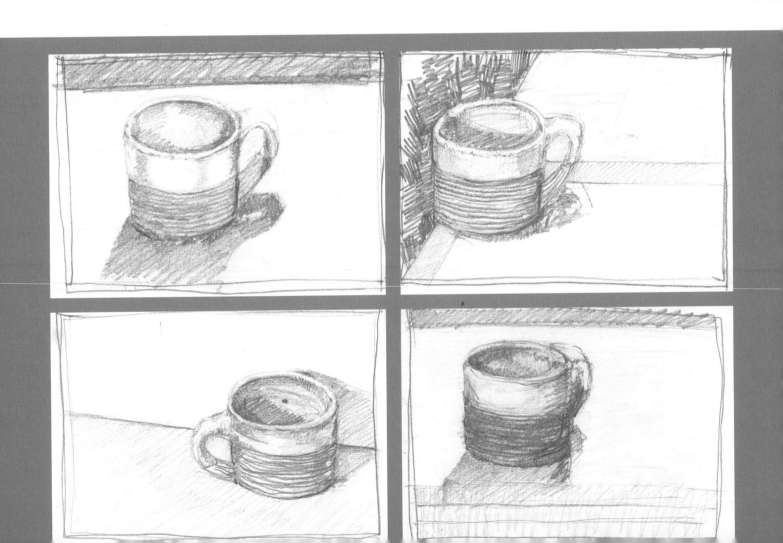

88 WORDS, TEXT AND LETTERS

Words, text and letters can be included in our sketchbooks, to annotate our work but also as a subject in themselves. For me, a sketchbook is a learning tool, a place to experiment and have fun, and I often make myself notes, or record my feelings and thoughts on a piece.

Today, then, I want you to use words and text as the focus for your sketchbook page: words are the art itself rather than a side note. You could choose to create an illustrated or illuminated letter or word, write a poem or an affirmation (see pages 24–25) that means something to you, or spend some time journalling. Typography and lettering is a broad, interesting subject and can also cover calligraphy and hand- or brush-lettering, as well as book illustration. Give these a try, too, and see what happens!

SUSAN SAYS
Look at the following artists and artistic movements and see if any inspire you:
- Letterpress artists, such as Alan Kitching (b. 1940)
- Graffiti
- Barbara Kruger (b. 1945)
- The posters of Henri de Toulouse-Lautrec (1864-1901)
- Brush lettering
- Pop art and artists, such as Roy Lichtenstein (1923-1997)
- Illuminated letter art

TYPOGRAPHY
Typography is the art of arranging text to make written language legible, readable and appealing when displayed. Typography is applied to many things around us, from magazines, books and other printed materials to products and packaging, signs and banners, the internet and much more.

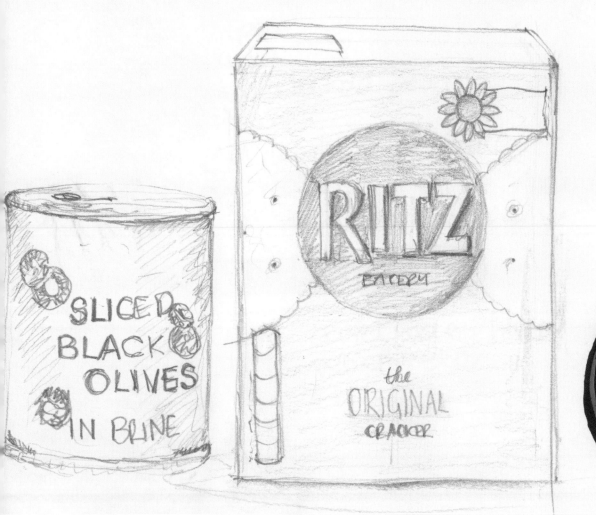

89 FOOD PACKETS

Examining food packets can quickly immerse you in the world of typography, lettering and design. We often overlook the carefully designed packaging of the food we eat, but they provide an almost limitless source of sketchbook fodder.

90 LIGHT AND DARK

Light and dark, and the contrast between the two, can be a wonderful subject matter for sketching. I love this quote by Paul Cézanne (1839–1906): 'There is no light painting or dark painting, but simply relations of tones'.

So, today, I want to share with you some information on tone, as this is helpful to understand and to apply to your work.

TONE

Tone, in art, refers to the *relative* lightness or darkness of a colour, and, basically means how light or dark something is. An understanding of tone is essential for artists, as it can really help to bring things to life on the page - colours can appear very flat without any consideration of tone.

Tone can make a piece look three-dimensional, which helps to create atmosphere, or a sense of depth and distance. In real life, tone is suggested by the way that the light falls on an object: the highlights have the lightest tones, and the shadows, the darkest tones. An object of a single colour, such as a blue ball, with a light source coming from one side, will display a range of tones, from the brightest highlights to the darkest shadows. There are a number of approaches to sketching based upon tone. See what you come up with yourself or try one of the two suggestions here (right, and below, in 'Susan says').

SUSAN SAYS

Place an object of a single colour in front of you, and place a strong light source next to it - you can sit the object directly next to a window. Observe the tones for a few moments. See how the highlights may appear to be a completely different colour from the shadows, when you know that the object itself is of one colour only. This is the effect of tone.
Now begin to sketch the object, focusing only on the areas of light and dark.

NINE TONES

The aim is to create nine areas of tone from light to dark.

TOOLS & MATERIALS

· Sketchbook page or sheet of paper
· Pencil
· Ruler
· Selection of tools for creating the tones (I used a mixture of drawing tools and mediums, including pencils, pens, charcoal, pastels and ink)

INSTRUCTIONS

1. Draw nine boxes, using a ruler and pencil. I drew 2.5cm (1in) squares.
2. Number the squares from 1 to 9; 1 will be the lightest tonal value and 9 the darkest.
3. With your first drawing tool, create a series of tones within the boxes, from light to dark, as shown opposite.
4. Do this again with your next drawing tool. Experiment with different ways of expressing tone on the page. In the chart opposite, I've used dots, lines, shading and cross-hatching (multiple lines crisscrossed over each other) to move from light to dark across the page.

I recommend using what you already have in terms of drawing tools: you don't need to go out and buy all the tools I have listed. You also don't need to make as many examples!

LIGHT **DARK**

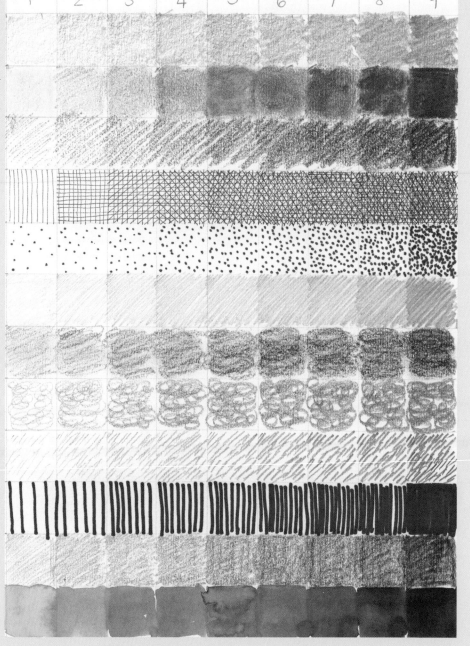

| 1 | 2 | 3 | 4 | 5 | 6 | 7 | 8 | 9 |

2B pencil

Charcoal

Soft pastel

0.1 fine-liner, hatching

Brush pen dots

3H pencil

Charcoal pencil

8B pencil

Blackwing soft matte pencil

Sharpie

Black watercolour pencil

Black watercolour ink

147

91 IN THE LABORATORY/ WEIRD SCIENCE

Today we go into the laboratory to look at a little weird science. See where your imagination takes you as we get scientific with our sketching.

Here, I carried out some line drawings with a fine-liner pen and then used some watercolour paint to add a little colour.

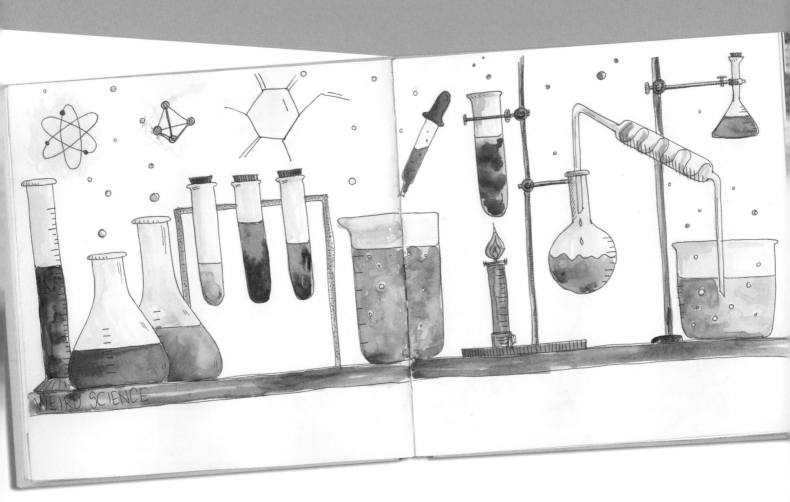

92
FAMILY

Today your inspiration is your family. Here are a few suggestions to get you started if you are stuck for what to draw. As always these are just ideas – you can, of course, sketch something else entirely.

- Draw a portrait of a family member – if they will sit still long enough;
- Make a sketch from a family photograph;
- Carry out some quick sketches of your family going about your daily lives;
- Sketch items or objects that remind you of your family;
- Draw from an old photograph of your ancestors;
- As a family, create a piece of art together in your sketchbook;
- Journal about what family means to you or create a piece of 'word art';
- Make a collage of photographs or memorabilia from family trips.

For this prompt, I left it to my four-year-old to draw our family in my sketchbook. (See 'Be like a toddler' on pages 20–21.) This sketch makes me smile so much, as it's our little family as seen through the eyes of my daughter (and yes, my blue hair is 100 per cent accurate!).

93 HOBBIES

Do you have a hobby? This is the starting point for your sketch today.

It could be that sketching itself is your hobby, or that you do something else for enjoyment. Think about what you could draw: it could be a single item, or a whole scene. For this sketching prompt, I decided to sketch my camera as I enjoy taking photographs as a hobby.

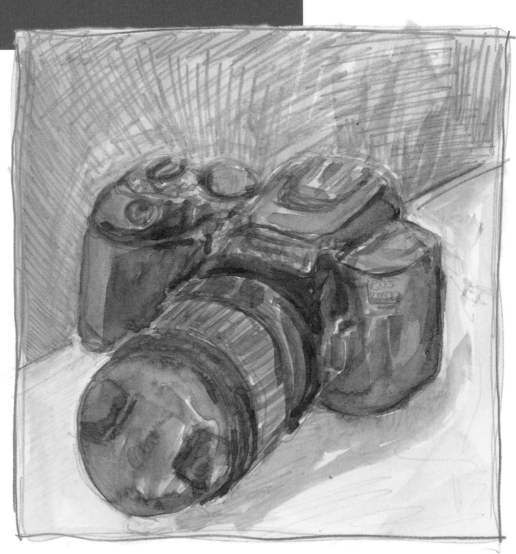

94 MONSTERS, GHOSTS AND GOBLINS

I think it's about time we looked at some curious creatures in the form of monsters, ghosts, goblins or even dragons. These supernatural creatures make for interesting prompts and can be fun to create.

For this prompt, you could make up some monsters of your own, or sketch a famous monster or ghoul.

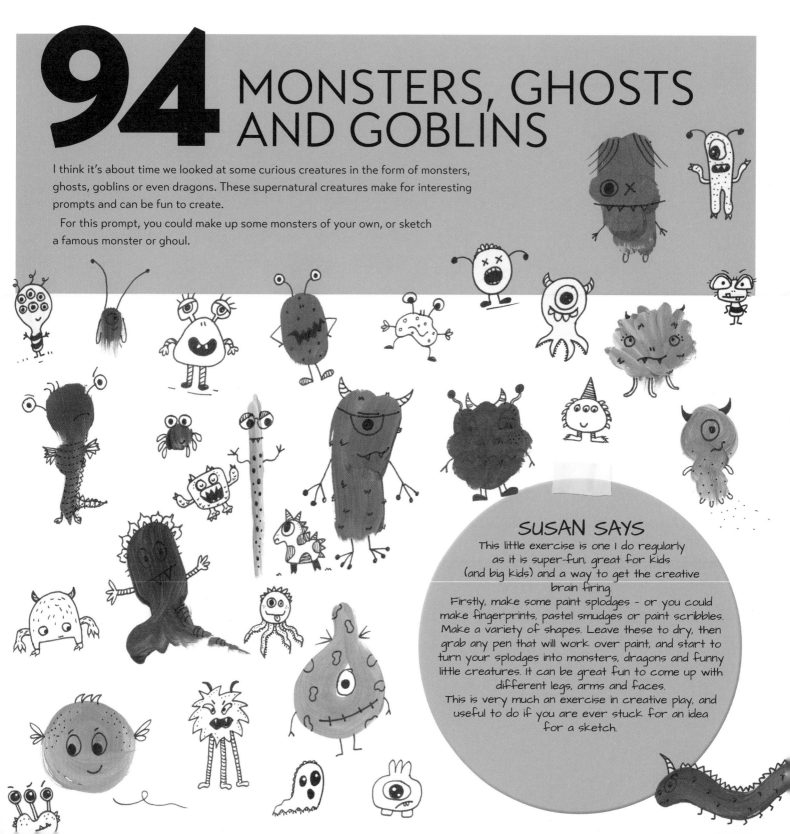

SUSAN SAYS

This little exercise is one I do regularly as it is super-fun, great for kids (and big kids) and a way to get the creative brain firing.

Firstly, make some paint splodges - or you could make fingerprints, pastel smudges or paint scribbles. Make a variety of shapes. Leave these to dry, then grab any pen that will work over paint, and start to turn your splodges into monsters, dragons and funny little creatures. It can be great fun to come up with different legs, arms and faces.

This is very much an exercise in creative play, and useful to do if you are ever stuck for an idea for a sketch.

95 HOLIDAY OR TRAVEL

Sketching while travelling or on holiday is an ideal way to use a sketchbook. Travel journals are popular with many artists, and I always take a sketchbook with me when I go abroad, or when I visit a new town or city, even if it's local to me.

Travel can provide you with new inspiration in the form of the places you visit, the things you see and the culture, which may be entirely different from your own. You can save this prompt for when you are actually on holiday or a short break, or you can also sketch from photographs of a previous holiday. You can interpret the prompt by depicting the process of travelling, or by sketching things that remind you of your holidays.

One of the most inspiring trips I have ever taken is to Barcelona in Spain. I first went there as an art student, and we were encouraged to sketch everything we saw rather than take photographs (this was a time before smartphones!). I still have these sketches today and they really evoke my personal view of the city – what I saw and the views and architecture that inspired me: the architecture of Antoni Gaudí (1852–1926) in the form of the Sagrada Família and the Güell Park, and the feel of the city was so inspiring to translate into drawings and sketches.

96 FABRIC

Today is the day to study and sketch some fabric. You could sketch the fabric of your clothes, design your own fabric, or study a folded piece of fabric to better understand how to represent it on the page. If you are drawing people, in many instances they will be clothed, and therefore you will need to paint or draw the fabric of their clothing.

Learning how to make fabric look realistic or how to add interest to a piece is a helpful skill for any artist.

DEMONSTRATION

SUSAN SAYS
This exercise is a great opportunity for exploring the shapes that fabric makes while folded or scrunched up; it is also a good chance to consider tone while you sketch: see pages 146–147 for more information on tone.

Range of tone

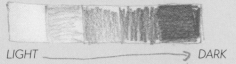

LIGHT ⟶ *DARK*

INSTRUCTIONS

1. Firstly, scrunch up some fabric and set it in front of you. Make sure you can see some good shapes and shadows – plain fabric works best, as you won't be distracted by any patterns.
2. Make a viewfinder out of paper (see page 131 – cut out a window to look at the fabric through the paper). Hold up the viewfinder in front of the fabric so you can't see its edges.
3. In your sketchbook, draw a box the same shape as your viewfinder window.
4. Draw five little boxes under the frame. In these boxes, sketch five tones varying from light to dark. This will be a handy reference for your tonal fabric sketch.
5. Start to sketch the fabric in the frame you've drawn in your sketchbook. Use light lines to mark out the major shapes.
6. Start adding the tones. Whether you start from light to dark or dark to light, or begin with mid-tones, it's up to you. The most important thing is to focus on the tonal values, using your five little tonal swatches as a reference. Do this for between 15 and 30 minutes so that you have time to consider the marks you make and build up the sketch slowly.

The fabric is abstracted by the viewfinder so that it doesn't look like fabric any more, making it more of a challenge to sketch. Really focus on the light and the dark areas, and on recording what you actually see.

97 ROOFTOPS

Rooftops can be fascinating to draw. You can keep them simple and go for a silhouette or outline, or go more complex and try a detailed study. The rooftops and skylines of every town and city will be unique, and provide endless inspiration.

To create the sketch below, I began by creating a loose painted sky using acrylic paint. I then took a soft pencil (2B) and loosely sketched out some rooftop forms from my imagination. Once this was done, I added some colour to the rooftops themselves. The sketch took around 10 minutes to do, and I used a large brush throughout to suit the size of the sketchbook page I was working on. This meant that my brushstrokes on this page had to stay loose rather than detailed.

I enjoy a loose, painterly way of working sometimes, in contrast to making finer pen and ink sketches (see 'Buildings' on page 80).

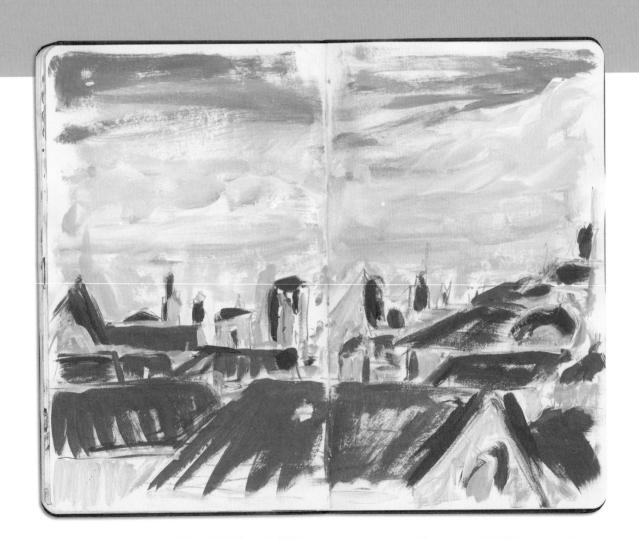

98 DANCE

Dance has been an inspiration for so many artists throughout history: Edgar Degas (1834–1917), a French Impressionist artist, in particular, was famous for his sketches, paintings and sculptures of ballet dancers.

With dance, you are looking not only at the human form, but also at the way in which that form moves to music. It is unlike any way in which the body moves in normal day-to-day life. Capturing dance on the page is all about capturing a fleeting movement and gesture – there can be some extravagant costumes and settings to depict, too!

If you have the chance to study people dancing, it can be a truly rewarding exercise. However, not all of us will have this opportunity, so sketching from a photograph, studying the paintings of the Old Masters or sketching paraphernalia related to dance are also viable options.

Or maybe you will choose to put down the sketchbook today and have a little dance around instead!

*Pencil sketch,
after Degas.*

99 HOME

The topic of home is what prompt 99 is all about: the place where you live: where you sleep, eat, and probably spend a lot of your time.

Here are some ideas for ways to tackle this prompt today:
- Create a detailed house portrait in colour;
- Carry out some quick and loose pen-and-ink sketches of your home (see my own house pictured left, drawn in this manner);
- Pick your favourite room or spot in your home and sketch that;
- Draw one of your previous homes;
- Sketch somewhere else in the world that you class as home;
- Sketch what you would want in your dream home;
- Use the word 'home' as a starting point for some quick thumbnail sketches of whatever comes into your head. Let your imagination roam free.

100 YOU

Well, I just had to finish this list of 100 sketching prompts with you. Yes, 'you'. Today I want you to look to yourself for inspiration. This could be a self-portrait or any other interpretation that you feel inclined to sketch.

The self-portrait is a popular subject matter in art. Why not create some sketches of yourself using a mirror or take a photograph of yourself and create a more detailed sketch from this?

Sketching a self-portrait can be tricky for even the most confident and accomplished of artists. Try spending just 30 seconds on a quick line drawing and see what happens. Maybe try again tomorrow for 60 seconds. Then try the day after, working with another drawing tool. You could fill a whole sketchbook with little self-portraits and studies.

AFTERWORD & NEXT STEPS

I truly hope that, having followed along with some (or even all) of the suggestions in this book, you have ideas to fill your sketchbooks for years to come.

The biggest tips I can give you going forward with your sketchbook practice are:

- Do small amounts regularly (in a small portable sketchbook, ideally);
- Don't be hard on yourself if things don't pan out as you'd like them to (refer to the 'Mindset and creativity' chapter if this is a constant battle for you);
- Have fun!

Don't forget, also, that it's OK to skip the stuff that you don't enjoy and do more of the stuff you love. I do it all the time. There are several prompts in this book that I fill whole sketchbooks with (and it was hard to decide which sketches to select to include) and others that I put off sketching until the very last minute. And that's perfectly normal as we are all different.

Always lean into your own likes and the things that spark your curiosity and creativity. As I've said before, I believe that a sketchbook is a place to experiment and explore possibilities. If you think of a finished piece of art (or even a finished sketch) as the tip of an iceberg, the work and studies in a sketchbook are the ice that lies under the surface.

SUSAN SAYS

Tackling all 100 prompts myself has reinvigorated my own sketching practice and I can think of at least five different prompts that I want to explore further. Why not try this yourself? Pick five of your favourite prompts from this book and dedicate a whole month or a whole sketchbook to each. Going deeper into a subject matter by sketching it several times will really build your sketching confidence. For example, if you use the prompt on pages 100–101, 'Trees, woods and forests', as a starting point, you can fill a whole sketchbook with little tree drawings from daily walks in nature.

To know what you enjoy sketching and what inspires you to get that sketchbook out and make marks, you must also have a good understanding of what you don't enjoy or find inspiring. Invigorate your sketching and creativity by pushing yourself out of your comfort zone and trying new things. Come back to this book as often as you need, and try out a prompt or an exercise you have not yet tackled.

I am aware that there is a *lot* of content in this book, so do take your time digesting it. There is no pressure to finish anything here and no medal for being the first to reach the end. Yes, it is amazing if you complete a sketch for every one of the 100 prompts, but there is a wealth of additional shorter challenges, warm-up exercises, 'Susan says' and further ideas hidden within the pages, all of which are worth your taking the time to explore, too.

This isn't the end – just the beginning of your sketching adventures.

Susan

▶ The prompts

1. Pattern
2. Everyday object
3. Lunch
4. Leaves
5. Boxes
6. Windows and doors
7. Shells
8. Birds
9. Pick a colour
10. Toys and games
11. Pens and pencils
12. Bottles
13. Flowers
14. Kitchen utensils
15. Balls
16. Butterflies and moths
17. Spots and dots
18. Something beginning with...
19. Transport
20. Fish/Under the sea
21. Vases, jugs and containers
22. Bugs and beasties
23. Mushrooms and fungi
24. Bags
25. Water
26. Fruit and veg
27. Buildings
28. Clocks, watches and time
29. Buttons and beads
30. Snowflakes
31. Garden
32. Something hot
33. Something cold

34. Mandalas
35. Shopping
36. Paint and paintbrushes
37. Numbers
38. Pets
39. Cacti and succulents
40. Clothes
41. Hands
42. Geometry
43. What's in your pocket?
44. Furniture
45. Float or sink
46. Cables and wires
47. Machines
48. Trees, woods and forests
49. Famous paintings
50. Famous landmarks
51. Work
52. Faces
53. Botanical study
54. Something that smells good
55. Something that smells bad
56. Jewellery
57. Technology
58. Sport
59. Feathers
60. A few of my favourite things
61. Landscape
62. Sci-fi and outer space
63. Coins and money
64. Kings and queens
65. TV and film
66. Something made of wood
67. Something made of glass

68. Street scene
69. Rubbish
70. Sweets and treats
71. Inspired by music
72. Café or restaurant
73. Seasonal celebrations
74. Stones, rocks and pebbles
75. Symbols and signs
76. Abstract
77. Wildlife
78. Clouds
79. The moon
80. Under the sink
81. The four seasons
82. Still life
83. Something old...
84. ...Something new
85. People-watching
86. Books
87. Something you used today
88. Words, text and letters
89. Food packets
90. Light and dark
91. In the laboratory/Weird science
92. Family
93. Hobbies
94. Monsters, ghosts and goblins
95. Holiday or travel
96. Fabric
97. Rooftops
98. Dance
99. Home
100. You